Samplers

FROM THE VICTORIA AND ALBERT MUSEUM

Samplers

FROM THE VICTORIA AND ALBERT MUSEUM

CLARE BROWNE AND JENNIFER WEARDEN

PHOTOGRAPHY BY CHRISTINE SMITH

First published by V&A Publications, 1999

V&A Publications
160 Brompton Road
London SW3 1HW

Clare Browne and Jennifer Wearden assert their moral right
to be identified as the authors of this book

Designed by Cara Gallardo, Area

ISBN 185177 290 1

A catalogue record for this book is available
from the British Library

Printed in Hong Kong by
Hong Kong Graphic and Printing Ltd

Photography by Christine Smith, V&A Photographic Studio

Cover illustrations
Front: Sampler, English; dated 1785 (Plate 56)
Back: Sampler, English, dated 1661 (Detail; plate 28)

Needlework kits inspired by the V&A's collections
are available from DMC Creative World Ltd, and
the V&A shop

Contents

6 Acknowledgements

7 Samplers in the Museum's Collection
by Clare Browne

12 List of Plates

25 The Plates

129 Stitches and Techniques
by Jennifer Wearden

136 Glossary
by Jennifer Wearden

144 Select Bibliography

Acknowledgements

We are very grateful for help in the preparation of this book from Marianne Ellis. We would also like to thank Noreen Marshall, Rachel Morse and Patricia Walker, together with our colleagues in the Textiles and Dress Department, in particular Helen Wilkinson.

Samplers in the Museum's Collection

BY CLARE BROWNE

SAMPLERS DERIVE THEIR English name from the Old French *essamplaire*, meaning any kind of work to be copied or imitated. Defying precise definition, the name has come to be used for a type of object whose form and function have comprehensively changed during the 300 years represented by the pieces illustrated here, from a practical tool of the embroiderer through decorative pictures to a formulaic or occasionally more individual schoolroom exercise.

Since its earliest acquisition of a sampler in 1863 (see plate 6), the Victoria and Albert Museum has built up a collection of over 700 examples, dating from the fourteenth or fifteenth century to the early twentieth century. Their range is extensive in country of origin and style, as well as date, reflecting the Museum's early and continuing recognition of the contribution made by samplers towards documenting the history of embroidery, its teaching and practice. It also reflects their widespread appeal to museum audiences and private collectors, whose gifts or bequests have significantly augmented the Museum's collection. Of particular importance has been the donation of samplers handed down through families, which come with their associated histories, as in the group of six related mid-seventeenth-century samplers given by descendants of Margret Mason, a young girl who worked her signed piece in 1660. Four of the samplers are shown as plates 18, 19, 20 and 25.

In their earliest form samplers were put together as personal reference works for embroiderers: trials of patterns and stitches that had been copied from others; records of particular effects achieved, which then could be recreated. They would have been the work, not of children, but of more experienced embroiderers, and some, from their quality, of professionals. Such stitch and pattern collections may have been assembled in a number of cultures where embroidery for decorative effect was widely practised, our knowledge of early examples depending on the rare pieces to have survived. The earliest examples in the Museum's collection (see plates 1 and 2), which were found in Egyptian burial grounds, probably date from the fourteenth or fifteenth century.

By the sixteenth century, samplers in England had a particular identity which the considerable number of references in contemporary literature and inventories suggest was readily understood.[1] A sampler was, in the definition of John Palsgrave's Anglo-French dictionary of 1530, an 'exampler for a woman to work by; exemple'. It was a source for her to refer to, of patterns and stitches, before the introduction and growing availability of printed designs. The first printed pattern book for embroidery was published by a textile printer, Johann Schönsperger in Augsburg, Germany, in 1524, and it was followed by others in Germany, and in Italy, France and England, which borrowed extensively from each other with or

without acknowledgement. The increasing availability of these books brought new patterns for embroiderers to apply to their work. Throughout the sixteenth century, however, the sampler retained its place as an effective memorandum, recording as well as the patterns themselves, the effects achieved by different stitches, types of thread and combinations of colour.

Although there are a number of references to samplers in sixteenth-century literature, surviving examples are exceptionally rare. Three from the Museum's collection are illustrated here. The German piece (see plate 4), undated, is worked mostly with ecclesiastical motifs that were probably intended for the decoration of church linen; the motifs are in the style of the earliest group of pattern books, from 1524 to 1540. Another undated piece is probably Italian (see plate 5); its central motif, with a design in reserve on a red embroidered ground, was first published in the *Esemplario di lavori* of Giovanni Andrea Vavassore in 1530, and it is surrounded with border patterns typical of those used in the sixteenth century for personal and household linen.

Jane Bostocke's sampler of 1598 is the earliest dated sampler known to have survived (see plate 3). Its inscription commemorates the birth of a child, Alice Lee, two years earlier; the quality of the embroidery is very high, and Jane Bostocke may have been a member of the family's household employed for her needlework skills. The sampler is from a period of transition in the practical use of such items, between their earlier role, when they served as reference pieces for more or less experienced embroiderers, and their developing nature in the seventeenth century as a method of measuring and recording their makers' attainments. The Jane Bostocke sampler has elements of two different sorts of needlework exercise, which developed in the following decades: the randomly placed working of individual motifs (usually described as spot samplers) and the more orderly arrangement of rows of border patterns (band samplers). Both of these types are well represented in the Museum's collection, with over 100 English examples from the seventeenth century.

Spot samplers appear closest in intention to the earlier reference pieces. The one illustrated in plate 7 shows a typical range of motifs, with areas of repeating pattern, some suitable for the decoration of linen or such costume accessories as purses, together with creatures taken from Richard Shorleyker's pattern book of 1624, *A schole-house, for the needle*, in which he advertises 'sundry sortes of spots, as flowers, Birdes and Fishes, &c'. Part-worked areas and evidence of unpicking in some of these samplers underline their use in trying out new effects, and they frequently display a wide range of stitches, as well as many colours of silk and different metal threads. Some contain initials, but rarely names or dates; the few dated examples, covering a wide span of years, indicate that such samplers were made through most of the 17th century.

By about 1630 a characteristic shape and size of sampler was becoming recognisable, with the ground cut from a loom-width of linen to form its length, and a much narrower width. The selvedges of the linen thus made up the top and bottom edges of the sampler. It would typically be filled with rows of repeating patterns worked in coloured silks, sometimes interspersed with figures or floral motifs. Some band samplers are entirely of whitework, cutwork and needle lace stitches, and others combine white and coloured decoration in the same piece, sometimes working from either end towards the middle, as in the unfinished example in plate 19. Plate 16 shows the earliest signed and dated band sampler in the Museum's collection, worked by Mildred Mayow in 1633. The sampler in plate 15 has at least two other closely similar versions known and may be an early example of a particular school or teacher's influence; with the composition of band samplers comes the first clear indication in England of the form being used as a method of instruction and practice for girls learning needlework.

Martha Edlin's two samplers, illustrated in plates 30 and 31 were worked in 1668 and 1669. The first is a lively band sampler in multicoloured silks, embroidered when she was eight, the second, more subtly patterned and technically sophisticated – with bands of cutwork and needle lace stitches, and whitework – when she was a year older. She went on to embroider the panels of a fine casket, also in the Museum's collection, by the time she was 11, and a beadwork jewel case when she was 13. The physical dating of all of these pieces suggests the desire to mark them as significant achievements in the stages of her girlhood learning.

The introduction of moral verses into the decoration of samplers is another indication of their place, well established by the middle of the seventeenth century, as part of a girl's education. The anonymous worker of the sampler in plate 27, who would almost certainly have been a child of similar age to Martha Edlin, relates that she must 'bow and bend unto another's will that I might learn both art and skill to get my living with my hands'. While many of the girls who embroidered these samplers would not have expected to have to work for their living, the needlework skills they were learning were still important attributes in the future management of their households and the personal adornment of their families and themselves. Alphabets gave practice for the marking of linen, and the spot motifs and border patterns could be put to use in the decoration of clothes and domestic furnishings. Some of the patterns that appear on later seventeenth-century samplers, however, displaying origins in sixteenth-century pattern books modified by repeated copying and adaptation, would have seemed very outdated by then, and can only have earned their place as part of the tradition of patterns handed on through generations. Elizabeth Mackett worked a fine sampler in 1696 (see plate 34), which was technically accomplished, but used needle lace stitches and patterns that were part of the repertoire 50 years earlier (see plate 21). The anonymous maker of the beautifully executed mid-seventeenth-century sampler in plate 23 worked an alphabet whose design came originally from *La vera perfettione del disegno* by Giovanni Ostaus (1561), and was reprinted in England by Poyntz, in *New and singular patternes and works of linnen*, in 1591.

The most curious of these pattern book motifs to appear regularly on English samplers, transformed through copying over many years from its original form, is the small figure given the name of 'boxer' by nineteenth-century collectors because of his stance with raised arm as if taking guard. He appears, repeating across a row, in samplers from the mid-seventeenth century (see plates 25 and 26) until well into the eighteenth (see plate 50). The figure of the 'boxer' is ultimately derived from the motif of a lover offering a flower to his lady, found in a number of versions in nineteenth-century pattern books. He is sometimes naked and sometimes dressed, giving his creator an

opportunity to express some individuality in colour choice and stitch (in plate 26 two 'boxers' stand back-to-back, eyeing each other like duellists), and the lady to whom he is making his offering has herself been transformed into a flowering plant.

A similarity of composition and motifs seen in another group of samplers dating from the late seventeenth and early eighteenth centuries, provides helpful evidence of the continuity brought to sampler-making by the influence of a teacher on her pupils over a number of years. The sampler shown in plate 40 was worked by Mary Groome in 1704. It is one of a group of 12 now known, in public and private collections, which were apparently worked by pupils of a teacher called Judeth (or Juda) Hayle in the Ipswich area.[2] The group range in date between 1691 and 1710, and between them share a number of the same motifs and patterns, as well as a moral verse, declaring that 'larnin is most excellent'. Each acknowledges the guidance of Judeth Hayle, either citing her as 'dame', or including her initials.

The seventeenth-century German and Italian samplers in the Museum's collection (see plates 35 to 39) are worked with repeating patterns and motifs that appear to have more practical application than their English counterparts, although there is less variety in the stitches used. The earlier examples may well be the practice or reference pieces of experienced embroiderers. One, signed Lucke Boten and dated 1618, is the earliest dated German sampler so far known (see plate 37).

The format of English samplers evolved in the early eighteenth century into a square shape, reflecting the further changing perception of their purpose. Combining in a single exercise the different stages that a girl would previously have gone through in the acquisition of needlework skills, when her task was to embroider one or two samplers followed by a panel or picture, the result was not a long, narrow piece to be rolled up for future reference, but something that could be displayed like a painting or print. The bands of repeating patterns and alphabets did sometimes still appear, with, occasionally, traditional pattern book motifs. In plate 44, dated 1729, two 'boxers' accompany couples fashionably dressed in the styles of more than 100 years earlier, taken originally from Johann Sibmacher's pattern book of 1601 *Newes*

Modelbuch, and reprinted a few years later by James Boler in *The needle's excellency*.

But increasingly samplers had a pictorial focus, such as the figure of Queen Anne in plate 41, or included lengthy inscriptions of moral or religious verse (see plate 45). Signifying their fitness for display, they would in effect be framed with embroidered border patterns, naturalistic in accordance with contemporary taste in textile design, or stylised with flower heads alternating regularly on each side of a stem, in a form that was to change very little over the next 100 years (see plates 49 and 84). By the mid-eighteenth century the motif of house and garden, personalised with added local detail (such as the windmill and dovecot in plate 51), had become, and was to remain, a favourite choice of subject.

The sampler dated 1719 in plate 43 was embroidered on a woollen ground, which was increasingly used for English samplers as the eighteenth century progressed. Its surface was easily worked with the diminishing range of stitches in the young girl's repertoire – tent stitch and cross stitch were her usual choice. A linen ground was retained, however, for a particular type of sampler worked in a needle lace stitch called hollie point or hollie stitch, most examples of which date from the second quarter of the eighteenth century (see plates 47 and 48). Hollie point was a practical stitch to learn, used particularly for decorative insertions into baby clothes and occasionally adult garments, and exact counterparts of the patterns worked in hollie point samplers can be found in surviving clothing. The maker of the large sampler shown in plate 50 also had a practical purpose in mind: her experimentation with a flame effect in different stitches was probably intended for upholstered chair seat covers. From its colouring and lettering this sampler is almost certainly Scottish.

Samplers in which the maker demonstrated her darning skills provide evidence of the continuing thread of utility still to be found in sampler-making in the later eighteenth century. The range of English darning samplers in the Museum's collection, with points of similarity and of contrast, underlines the varying circumstances of the girls who made them. The anonymous embroiderer of the sampler in plate 54 chose a variety of pastel-coloured silks for her work, and filled the centre of the sampler with a delicate ribbon-tied spray of flowers. Eliza Broadhead, a pupil at the Quaker school in Ackworth, Yorkshire, in 1785, used similar pattern darning stitches, but in predominantly brown wool on a coarse woollen ground, achieving a more starkly utilitarian effect (see plate 55). Elaborate darning samplers were also worked in the Netherlands, possibly the source from which English versions derived (see plates 67 and 69); they are more usually signed and dated than English ones, however.

The establishment of sampler-making as part of a girl's school education gave scope for the demonstration of more than just her needlework skills and the expression of dutiful piety. Elizabeth Knowles' sampler of 1787, illustrated on plate 57, is worked with a 'Perpetual Almanack', from which the dates of every Sunday for the succeeding 50 years might be calculated. Its careful layout, mathematical precision, Latin tag and naming of the school where she was a pupil suggest her desire to show off other attainments as much as her embroidery, which is worked unambitiously in cross stitch throughout. Geography was also considered a suitable vehicle for the combined demonstration of academic and needlework skills. Samplers depicting maps, at first drawn onto the canvas by the pupil or her teacher (see plate 61), became so popular that printed satin versions could be purchased ready to embroider (see plate 60). A rare introduction of astronomy into a needlework exercise appears in an unsigned example dated 1811 (see plate 78). It shows the planets of the solar system with their temporal and spatial relationships to the sun calculated, and the 'Orbit of the Comet'.

The eighteenth-century European samplers in the Museum's collection reflect a range of different preoccupations among their makers. Two of the Scandinavian examples illustrated (see plates 63 and 64), both dating from the 1750s, continue in the tradition of stitch and pattern exercises. A Dutch sampler from 1751 (see plate 66) shows experimentation with traditional border patterns, elaborate lettering and strong colours typical of Friesland. Among the Museum's extensive collection of Spanish samplers the three illustrated here (see plates 70 to 72) are in the style that predominated from the later seventeenth to the nineteenth centuries – large, densely worked with geometric

patterns and figurative motifs in a variety of stitches, and often inscribed with the teacher's name alongside that of the maker.

The pair of samplers shown in plates 73 and 74, worked by two English sisters, show how effectively a little creativity could still personalise what was becoming increasingly a standardised form of unambitious exercise in the early nineteenth century. Exceptions to this form call particular attention to their makers. The anonymous embroiderer of the sampler in plate 77 chooses to reveal nothing of herself except her touching affection for her father, among a scattering of random motifs. Elizabeth Parker[3] (see plate 81), on the other hand, uses the format of embroidery, worked in cross stitch in red silk on a linen ground in a block of text unrelieved by any ornamentation, to confess to all the errors of her short life, fixing the reader's attention with the most direct opening appeal 'As I cannot write I put this down simply and freely as I might speak to a person to whose intimacy and tenderness I can fully intrust myself and who I know will bear with all my weaknesses.'

Such a personal declaration is unique among the Museum's sampler collection, but the inclusion of more orthodox moral or religious texts in samplers, first seen in England in the mid-seventeenth century, continued to be a frequent choice in their composition through the first half of the nineteenth. The practice had been taken to America by English settlers, and absorbed into that country's developing sampler-making tradition (see plate 62); an example from 1840 (see plate 88), worked in the West African country of Sierra Leone, then a British colony, is evidence of the place such combined lessons in needlework and the precepts of morality still had at that date in British education transplanted abroad.

As well as acquiring samplers of the school-exercise type worked in much of Europe and in the colonial possessions of European countries (see plates 91 to 94), the Museum has actively collected samplers with particular regional characteristics. Some of these were already of historical interest when they were acquired, such as the example dated 1807 worked in black cotton on linen ground in the typical patterns of the Vierlande area of North Germany (see plate 90). Others were acquired by the Museum in the nineteenth century as records of current practice. The sampler predominantly of cutwork and drawn thread work made in the Swedish province of Skania in 1863 (see plate 96), was given to the Museum by the textile historian Mrs Bury Palliser in 1869. The German drawn thread work sampler in plate 97 was one of a group bought new from the *Gewerbeschule für Mädchen*, Hamburg, a training school for girls, in 1885. Nineteenth-century Turkish and Moroccan samplers (see plates 98 to 100), with their randomly placed patterns suitable for the decoration of household linen and clothing, serve to recall the early function of European samplers as collections of designs and stitch effects.

Samplers did not sustain their role much beyond the middle of the nineteenth century in the education of girls for whom embroidery would be a pastime or housekeeping ritual in adult life rather than a livelihood. The exercise in Berlin woolwork in plate 89, embroidered in counted thread stitches on a double canvas, may be professional work, intended as a model for amateurs to follow, and it is largely with such demonstration pieces that the tradition of sampler-making is represented in the Museum's collection into the twentieth century.

NOTES

1. This introduction draws extensively on research by previous curators in the Department of Textiles, in particular PG Trendell and Donald King. A comprehensive account of the most notable early references is given in King (1960).

2. This information on Judeth Hayle is from research in progress kindly supplied by Edwina Ehrman, at the Museum of London, which has samplers from the series in its collection.

3. Elizabeth Parker's identity has been established by Nigel Llewellyn of the University of Sussex and was discussed in his paper at the Material Memories conference, V&A, April 1998.

List of Plates

Those inscriptions are given that include names, initials or dates.
Only the predominant stitches are listed.

PLATE 1
T.326-1921
Egyptian (Mamluk); 14th to 16th century
Linen embroidered with silk in double running stitch
42.5 x 22.8 cm (16¾ x 9 in)
Given by GD Hornblower

PLATE 2
T.135-1928
Egyptian (Mamluk); 15th to 16th century
Linen embroidered with silk in double running stitch and
pattern darning
21 x 16.5 cm (8¼ x 6½ in)
Given by Mrs FH Cook

PLATE 3
T.190-1960
English; 1598
Linen embroidered with silk and metal thread in back, cross,
satin, detached buttonhole and plaited braid stitch with
couched metal thread and with pearls and beads
Inscription: *Jane Bostocke 1598 / Alice Lee was borne the 23 of
November being tuesday in the after noone 1596*
42.6 x 36.2 cm (16¾ x 14¼ in)

PLATE 4
T.114-1956
German; first half 16th century
Linen embroidered with silk in cross and
long-armed cross stitch
86.4 x 50.8 cm (34 x 20 in)
Given by Admiral Sir Robert and Lady Prendergast

PLATE 5
T.14-1931
Italian; 16th century
Linen embroidered with silk in back and
long-armed cross stitch
80 x 47 cm (31½ x 18½ in)

PLATE 6
9047-1863
English; first quarter 17th century
Linen embroidered with silk and metal thread in tent,
long-armed cross, Romanian and plaited braid stitch with
knots and pulled thread work
Inscription: *I R* (for James Rex, King James I)
61.6 x 21.6 cm (24¼ x 8½ in)

PLATE 7
Circ.279-1923
English; second quarter 17th century
Linen embroidered with silk and metal thread in tent,
Florentine, Hungarian, Montenegrin cross, rococo and
Romanian stitch with eyelets
50.2 x 31.1 cm (19¾ x 12¼ in)

PLATE 8
T.20-1913
English; first half 17th century
Linen embroidered with silk and metal thread in back, tent,
Florentine, Hungarian, rococo and plaited braid stitch with
eyelets and knots
Inscription: *M J*
50.8 x 30.5 cm (20 x 12 in)

PLATE 9
T.80-1918
English; first half 17th century
Linen embroidered with silk and metal thread in tent,
Romanian, rococo and plaited braid stitch with
eyelets and knots
44.5 x 22.5 cm (17½ x 8¾ in)
Given by Francis C Eeles

PLATE 10
T.36-1927
English; first half 17th century
Linen embroidered with silk and metal thread in long-armed
cross, tent, Hungarian, Romanian, rococo and plaited braid
stitch with pulled thread work, eyelets and knots
49.5 x 20.3 cm (19½ x 8 in)

PLATE 11
T.234-1928
English; mid-17th century
Linen embroidered with silk and metal threads in tent, rococo,
Romanian and plaited braid stitch with pulled thread work
77.5 x 29.2 cm (30¼ x 11½ in)

PLATE 12
T.40-1955
English; mid 17th century
Linen embroidered with silk in back, Hungarian and rococo
stitch with pulled thread work and eyelets
52.7 x 16.5 cm (20¾ x 6½ in)
Given by the Misses Alexander through the
National Art Collections Fund

PLATE 13
T.262-1927
English; mid-17th century
Linen embroidered with silk in rococo and
Romanian stitch with eyelets
51.4 x 20.3 cm (20¼ x 8 in)

PLATE 14
T.230-1929
English; first half 17th century
Linen embroidered with silk in running and
double running stitch
28.6 x 48.3 cm (11¼ x 19 in)
Given by Mrs Lewis F Day

PLATE 15
516&A-1877
English; first half 17th century
Linen embroidered with silk in double running, two-sided
Italian cross, padded Romanian, detached buttonhole stitch
93.9 x 20.3 cm (37 x 8 in)

PLATE 16
T.194-1927
English; dated 1633
Linen embroidered with silk in double running,
cross and Montenegrin cross stitch
Inscription: *Mildred Mayow 1633*
68 x 17.2 cm (26¾ x 6¾ in)
Given by Muriel Gardiner

PLATE 17
739-1899
English; mid-17th century
Linen embroidered with silk in double running stitch
Inscription: *AB*
86.4 x 15.2 cm (34 x 6 in)

PLATE 18
T.185-1987
English; mid-17th century
Linen embroidered with silk in double running
stitch with knots
60.5 x 14.5 cm (23^{13}/$_{16}$ x 5^{3}/$_{4}$ in)
Given by Janet Harris, Susan Jones and Lynda Smith

PLATE 19
T.184-1987
English; mid-17th century
Linen embroidered with silk and linen in double running
stitch with cutwork
88.3 x 12.7 cm (34^{3}/$_{4}$ x 5 in)
Given by Janet Harris, Susan Jones and Lynda Smith

PLATE 20
T.187-1987
English; mid-17th century
Linen embroidered with silk and linen in double running and
long-armed cross stitch with pulled thread work
45.5 x 20.5 cm (18 x 8 in)
Given by Janet Harris, Susan Jones and Lynda Smith

PLATE 21
Circ.110-1909
English; dated 1647
Linen embroidered with linen, with cutwork, pulled thread
work and eyelets
Inscription: *Mary Pritchard 1647*
45.7 x 19.7 cm (18 x 7^{3}/$_{4}$ in)

PLATE 22
T.115-1956
English; dated 1649
Linen embroidered with linen, with cutwork and
drawn thread work
Inscription: *S ID 1649 AI*
46.4 x 17.1 cm (18^{1}/$_{4}$ x 6^{3}/$_{4}$ in)
Given by Admiral Sir Robert and Lady Prendergast

PLATE 23
269-1898
English; mid-17th century
Linen embroidered with silk and linen in double running and
satin stitch with cutwork, drawn thread work and eyelets
96.5 x 16.5 cm (38 x 6^{1}/$_{2}$ in)

PLATE 24
742-1899
English; first half 17th century
Linen embroidered with linen, with cutwork and drawn
thread work
61 x 24.8 cm (24 x 9^{3}/$_{4}$ in)

PLATE 25
T.182-1987
English; dated 1660
Linen embroidered with silk in double running, long-armed
cross, Montenegrin cross, two-sided cross, satin, chain and
detached buttonhole stitch with eyelets
Inscription: *Margret Mason 1660*
72.5 x 17.5 cm (28^{1}/$_{2}$ x 6^{7}/$_{8}$ in)
Given by Janet Harris, Susan Jones and Lynda Smith

PLATE 26
T.217-1970
English; dated 1660
Linen embroidered with silk and linen in cross,
two-sided Italian cross, satin, rococo and detached buttonhole
stitch with drawn thread work and knots
Inscription: *M D 1660*
64.1 x 21.6 cm (25¼ x 8½ in)
Given by Lord Cowdray

PLATE 27
480-1894
English; second half 17th century
Linen embroidered with silk in satin, two-sided Italian cross
and detached buttonhole stitch with eyelets
68.6 x 19.7 cm (27 x 7¾ in)

PLATE 28
T.131-1961
English; dated 1661
Linen embroidered with silk, linen and metal thread in back,
cross, two-sided Italian cross, satin, plaited braid and
detached buttonhole stitch with cutwork
Inscription: *Elizabeth Short 1661*
62.2 x 20.3 cm (24½ x 8 in)
Given by Mrs Q Toogood in memory of CR Abbott

PLATE 29
570-1898
English; dated 1664
Linen embroidered with silk in double running, cross, two-
sided cross and Montenegrin cross stitch
Inscription: *Sarah Blake 1664*
89 x 22.8 cm (35 x 9 in)

PLATE 30
T.433-1990
English; dated 1660
Linen embroidered with silk in double running, cross, two-
sided cross, long-armed cross and satin stitch with eyelets
Inscription: *Martha Edlin 1668*
81.9 x 21 cm (32¼ x 8¼ in)
Purchased with the assistance of the National Art Collections
Fund and the National Heritage Memorial Fund

PLATE 31
T.434-1990
English; dated 1669
Linen embroidered with silk and linen in satin
stitch with cutwork
Inscription: *M E 1669*
38.1 x 23.5 cm (15 x 9¼ in)
Purchased with the assistance of the National Art Collections
Fund and the National Heritage Memorial Fund

PLATE 32
T.124-1992
English; dated 1678
Linen embroidered with silk and linen in two-sided cross and
two-sided Italian cross stitch with cutwork and eyelets
Inscription: *1678*
67.3 x 21 cm (26½ x 8¼ in)
Given by Margaret Simeon

PLATE 33
T.214-1911
English; dated 1681
Linen embroidered with silk in cross, two-sided
Italian cross, long-armed cross, satin and detached
buttonhole stitch with eyelets
Inscription: *Margreet Lucun 1681 being ten year old
come july the first*
43.2 x 26.7 cm (17 x 10½ in)
Given by Miss A L Dixon

PLATE 34
433-1884
English; dated 1696
Linen embroidered with silk and linen in cross, two-sided
Italian cross, satin, rococo and detached buttonhole stitch
with cut work and eyelets
Inscription: *Elizabeth Mackett 1696*
109.3 x 24 cm (43 x 9½ in)

PLATE 35
T.126-1992
Italian; first half 17th century
Linen embroidered with linen, with cutwork, drawn
thread work and buttonholed bars
34.3 x 13.3 cm (13½ x 5¼ in)
Given by Margaret Simeon

PLATE 36
T.787-1919
Italian; first half 17th century
Linen embroidered with linen and metal thread in satin stitch
with cutwork, drawn thread work and buttonholed bars
Inscription: *Gvllia Piccolomini*
81.3 x 44.4 cm (32 x 17½ in)

PLATE 37
T.41-1951
German; dated 1618
Linen embroidered with silk and linen in double running,
Montenegrin cross, two-sided Italian cross and satin stitch
with cutwork, drawn thread work and buttonholed bars
Inscription: *Lucke Boten anno 1618*
53 x 56 cm (20⅞ x 22 in)
Bequeathed by AG Hemming

PLATE 38
368-1907
German; dated 1661
Linen embroidered with silk in double running, cross and
long-armed cross stitch with eyelets
Inscription: *M M V 1661*
93.4 x 28.5 cm (36¾ x 11¼ in)

PLATE 39
104-1880
German; dated 1688
Linen embroidered with silk in cross, tent, satin and rococo
stitch with eyelets
Inscription: *D M W 1688*
59 x 22.9 cm (23¼ x 9 in)

PLATE 40
T.125-1992
English; dated 1704
Linen embroidered with silk in cross, long-armed cross and
satin stitch with eyelets
Inscription: *Mary Groome / September the 9 1704 aged 17 / I G
I H G I H M G*
79.3 x 14.6 cm (31¼ x 5¾ in)
Given by Margaret Simeon

PLATE 41
T.77-1916
English; early 18th century
Linen embroidered with silk and metal thread in cross,
satin, split and chain stitch
Inscription: *A R* (for Anne Regina, Queen Anne)
31.8 x 22.8 cm (12½ x 9 in)
Given by Frank Green

PLATE 42
145-1907
English, dated 1710
Linen embroidered with silk in tent, Florentine, Gobelin,
satin, stem, chain and buttonhole stitch with eyelets
Inscription: *Martha Wheeler her sampelr september the 15 1710 /
aged 12 years the 2 day of last march*
47.6 x 26.7 cm (18¾ x 10½ in)

PLATE 43
T.22-1955
English; dated 1719
Wool embroidered with silk in cross and satin
stitch with eyelets
Inscription: *Grace Catlin 1719*
30.5 x 21.7 cm (12 x 8½ in)
Given by Dr CG Smith

PLATE 44
T.291-1916
English; dated 1729
Linen embroidered with silk in cross stitch
Inscription: *Mary Smith her work made in the year of our Lord 1729*
26 cm x 29.9 (10¼ x 11¾ in)
Given by Frances M Beach

PLATE 45
T.318-1960
English; dated 1737
Wool embroidered with silk in cross, tent and satin stitch
Inscription: *Mary Flexney her work 1737*
33.6 x 23.5 cm (13¼ x 9¼ in)
Given by Miss MC Sparrow from the collection
of Miss Marjory Bine Renshaw

PLATE 46
T.57-1922
English; second quarter 18th century
Linen embroidered with silk in tent, two-sided cross and
encroaching satin stitch
Inscription: *Mary Stafford finishd this work in the year [of] our Lord*
36.8 x 33 cm (14½ x 13 in)
Given by Emma Monteith

PLATE 47
T.608-1974
English; dated 1739
Linen embroidered with silk and linen in satin stitch with
cutwork and hollie stitch
Inscription: *Mary Tredwel 1739*
29 x 29 cm (11⁷⁄₁₆ x 11⁷⁄₁₆ in)
Bequeathed by Mary Blanche Dick

PLATE 48
T.22-1944
English; second quarter 18th century
Linen embroidered with silk in back, cross, satin and rococo
stitch with cutwork with hollie stitch and with knots
Inscription: *Hannah Haynes her work*
20.3 x 20.3 cm (8 x 8 in)
Given by Miss M Brown

PLATE 49
391-1878
English; dated 1742
Wool embroidered with silk in cross and satin
stitch with eyelets
Inscription: *Mary Wakeling ended this December the tenth 1742
aged ten years*
30.5 x 30.5 cm (12 x 12 in)
Given by Mrs EC Leggatt

PLATE 50
T.205-1929
Scottish or English; dated 1749
Linen embroidered with silk and wool in double running,
tent, Florentine, two-sided cross and rococo stitch with eyelets
Inscription: *WK MB WR EK MK RG IK MR CK 1749*
43.2 x 31 cm (17 x 12¼ in)
Given by Mrs Lewis F Day

PLATE 51
288-1886
English; dated 1752
Wool embroidered with silk in cross and tent stitch
Inscription: *Elizabeth Cridland 1752*
33.7 x 24.7 cm (13¼ x 9¾ in)
Given by Miss Edmands

PLATE 52
T.46-1970
English; dated 1780
Wool embroidered with silk in cross and satin stitch
Inscription: *Sarah the daughter of William and Sarah Brignell was
born October the 24 in the year of our Lord 1769 / My sampler
finished Feb the 2 day 1780*
47.6 x 32 cm (18¾ x 12½ in)
Bequeathed by Dame Ada MacNaughton

PLATE 53
T.56-1948
English; dated 1784
Linen embroidered with silk in cross, two-sided cross,
Gobelin and satin stitch with eyelets
Inscription: *Eleanor Speed began this sampler Debr 12 1783 /
Eleanor Speed finished this May the 6 1784*
45.7 x 21 cm (18 x 8¼ in)
Given by Miss ER Carey

PLATE 54
T.36-1945
English; late 18th century
Cotton embroidered with silk in pattern darning
and stem stitch
29.2 x 24.8 cm (11½ x 9¾ in)
Given by Alice Haldane

PLATE 55
T.731-1997
English; dated 1785
Wool embroidered with silk and wool in pattern
darning and cross stitch
Inscription: *Eliza Broadhead Ackworth School 1785*
23.5 x 23.5 cm (9¼ x 9¼ in)
Bequeathed by Alison Brown

PLATE 56
T.750-1974
English; dated 1785
Wool embroidered with silk in running, cross and
chain stitch
Inscription: *Elizabeth Brain 1785*
33 x 43.2 cm (13 x 17 in)
Bequeathed by Miss KM Boden

PLATE 57
T.75-1925
English; dated 1787
Linen embroidered with silk in cross stitch
Inscription: *Elizabeth Knowles fecit Walton School 1787*
39.4 x 32.4 cm (15½ x 12½ in)
Given by J Falcke

PLATE 58
T.292-1916
English; dated 1789
Wool embroidered with silk in cross stitch
Inscription: *Mary Ann Body her work in ye 9 year of her age 1789*
35.6 x 31.75 cm (14 x 12½ in)
Given by Frances M Beach

PLATE 59
497-1905
English; dated 1780
Linen embroidered with silk in tent and cross stitch
Inscription: *Ann Rhodes April the 26 1780 in the*
13th year of her age
62.2 x 54.6 cm (24½ x 21½ in)
Given by Joseph Williamson

PLATE 60
T.44-1951
English; late 18th century
Silk embroidered with silk in running, outline, split, stem,
satin and long and short stitch
45 x 64 cm (17¾ x 25³⁄₁₆ in)
Bequeathed by Mrs IMC Robinson

PLATE 61
T.165-1959
English; dated 1797
Wool embroidered with silk in cross and chain stitch
Inscription: *done at Miss Powells Boarding School Plymouth by*
Elizabeth Hawkins 1797
50.8 x 58.4 cm (20 x 23 in)
Given by Miss AP Rean

PLATE 62
T.30-1923
American; dated 1794
Linen embroidered with silk in cross, satin,
surface satin and chain stitch
Inscription: *Lucy Symonds aged eleven years Boxford*
August ye 13 1796
62.2 x 54.6 cm (24½ x 21½ in)
Given by Mrs Antrobus

PLATE 63
T.59-1914
Danish or Swedish; dated 1751
Linen embroidered with silk, wool and metal thread in cross,
tent, brick, Florentine and rococo stitch with padded and
couched metal thread
Inscription: *A G T anno 1751*
77.5 x 65.4 cm (30½ x 25¾ in)

PLATE 64
T.27-1940
Danish; dated 1758
Cotton embroidered with silk, with pulled thread work
Inscription: *Rebeckea Asg[] n 1758*
34.3 x 36.8 cm (13½ x 14½ in)
Given by Sir Francis Oppenheimer

PLATE 65
T.184-1921
Danish; dated 1798
Linen embroidered with silk in cross, tent and satin stitch
Inscription: *1798 AHH MKE (and other initials)*
38 x 35 cm (15 x 13¾ in)
Given by Mrs Grove

PLATE 66
T.285-1960
Dutch; dated 1751
Linen embroidered with silk in straight and satin
stitch with eyelets
Inscription: *anno 1751 RS SI MT* (and other initials)
31.7 x 50.8 cm (12½ x 20 in)

PLATE 67
T.186-1921
Dutch; dated 1763
Cotton embroidered with silk in pattern darning and cross
stitch with eyelets
Inscription: *anno 1763 Gerarda Gerritsen BY SS*
36.8 x 36.8 cm (14½ x 14½ in)
Given by Mrs Grove

PLATE 68
T.283-1960
Dutch; dated 1782
Linen embroidered with silk in cross stitch
Inscription: *anno 1782 IMV DH*
36.8 x 34.3 cm (14½ x 13½ in)

PLATE 69
T.95-1934
Dutch; dated 1803
Cotton embroidered with silk in pattern darning and
cross stitch with eyelets
Inscription: *door myn Gedaan Maria Praag door het onderwys van /
Sara Detroi weduwe Ooms Geeyndict den 12 Mey anno 1803*
(Made by me Maria Praag under the instruction of Sara de
Troi widow Ooms finished the 12 May in the year 1803)
47 x 48.3 cm (18½ x 19 in)
Given by George D Pratt

PLATE 70
T.129-1909
Spanish; dated 1756
Linen embroidered with silk in double running,
long-armed cross, satin, straight, stem and chain stitch with
drawn thread work
Inscription: *Dona Isabel Evlogia de la Espada Loacavo ano de 1756*
(Doña Isabel Eulogia de la Espada finished it in the year
1756)
73.7 x 69.8 cm (29 x 27½ in)

PLATE 71
T.84-1931
Spanish; 18th century
Linen embroidered with silk in double running, satin and
chain stitch with knots
Inscription: *Dona D Los Reyes Armenta Vixano*
85.7 x 54.6 cm (33¾ x 21½ in)
Bequeathed by AP Maudslay

PLATE 72
609-1884
Spanish; 18th or early 19th century (dated but unclear)
Linen embroidered with silk in back, cross, long-armed cross,
satin, straight and Florentine stitch
Inscription: *Me izo Dona Ramona Erizarde siendo su maestra Dona
Luisa Toroca II / Edelhorno de San Matias ano di 1812 [?]*
(Doña Ramona Erizarde made me, her teacher being Doña
Luisa de Toroca Edelhorn de San Matias, in the year 1812)
66 x 69.8 cm (26 x 27½ in)

PLATE 73
T.96-1939
English; dated 1800
Wool embroidered with silk in cross and satin stitch
Inscription: *Mary Ann Richards her work June the first 1800*
48.3 x 32.4 cm (19 x 12¾ in)
Given by Lady Mary St John Hope

PLATE 74
T.97-1939
English; circa 1800
Wool embroidered with silk in cross and
satin stitch with knots
Inscription: *Elizabeth Jane Richards her work*
48.3 x 33.7 cm (19 x 13¼ in)
Given by Lady Mary St John Hope

PLATE 75
942-1897
English; dated 1803
Linen embroidered with silk in cross stitch
Inscription: *Elizabeth Smith her sampler done in the 11th year of her
age & in AD 1803*
42.5 x 42.5 cm (16¾ x 16¾ in)

PLATE 76
590-1894
English; dated 1806
Wool embroidered with silk in cross stitch
Inscription: *Charlotte Roy her work in the 10th year of her age 1806*
50.8 x 33 cm (20 x 13 in)

PLATE 77
1373-1900
English; early 19th century
Linen embroidered with silk in cross and satin stitch
20.3 x 32.4 cm (8 x 12¾ in)

PLATE 78
T.92-1939
English; dated 1811
Wool embroidered with silk in running and cross stitch
35.5 x 31.8 cm (14 x 12½ in)
Given by Lady Mary St John Hope
In the collection of the National Museum of Childhood at
Bethnal Green, a branch museum of the V&A

PLATE 79
T.4-1942
English; dated 1814
Wool embroidered with silk in cross, satin, long and short
and stem stitch
Inscription: *Sarah Ann Flude aged 10 years Anno Domini 1814*
44.5 x 38.2 cm (17½ x 15 in)
Given by Lucy Clement

Plate 80
T.133-1961
English; dated 1827
Wool embroidered with silk in cross stitch with eyelets
Inscription: *Sarah Grace Febry 13 1827*
31.7 x 30.5 cm (12½ x 12 in)
Given by Mrs Q Toogood in memory of CR Abbott

PLATE 81
T.6-1956
English; circa 1830
Linen embroidered with silk in cross stitch
85.8 x 74.4 cm (33¾ x 29¼ in)

PLATE 82
T.40-1928
English; 1830s
Wool embroidered with silk in cross and Gobelin stitch
Inscription: *Horse Hill House near London / Sophia Stephens June
30 183[] aged [] years*
55.9 x 54 cm (22 x 21¼ in)

PLATE 83
T.3-1930
English; 1837
Wool embroidered with silk in cross stitch
Inscription: *Eliza Richardson aged 10 years 1837*
42 x 31.8 cm (16½ x 12½ in)
Given by Mrs EM Baillie

PLATE 84
T.250-1920
English; dated 1839
Wool embroidered with silk in cross and straight stitch
Inscription: *Mary Pether 1839*
33 x 40 cm (13 x 15¾ in)

PLATE 85
T.102-1939
English; dated 1839
Wool embroidered with silk in cross stitch
Inscription: *Emma Susanna Matthew aged 10 years May 1839*
37.5 x 32.5 cm (14¾ x 12¾ in)
Given by Lady Mary St John Hope

PLATE 86
T.94-1939
English; *circa* 1836–40
Cotton embroidered with silk in cross stitch
Inscription: *Thomas Markham Son of William & Mary Markham /
married in the year 1826 to Elizabeth Boldero Daughter of Simon &
Elizabeth Boldero / their children in rotation of birth* [ten names fol-
low with dates of birth or death] / *Worked by S Stearn*
31.1 x 22.9 cm (12¼ x 9 in)
Given by Lady Mary St John Hope

PLATE 87
T.6-1935
English; mid-19th century
Wool embroidered with silk in cross stitch
Inscription: *Elizabeth Musto her work aged 14 years*
68.5 x 52 cm (27 x 20½ in)
Given by W Musto
In the collection of the National Museum of Childhood at
Bethnal Green, a branch museum of the V&A

PLATE 88
T.54-1934
British Colonial (Sierra Leone); dated 1840
Wool embroidered with silk in cross stitch
Inscription: *Lucy Grant Regent Town Sierra Leone October 15 1840*
33.7 x 24 cm (13¼ x 9½ in)
Given by William Barratt

PLATE 89
T.240-1967
English; mid-19th century
Cotton embroidered with wool and silk in cross stitch
133.4 x 21.5 cm (52½ x 8½ in)
Given by Mrs D McGregor

PLATE 90
510-1899
German (Vierlande); dated 1807
Linen embroidered with cotton in running and cross stitch
Inscription: *anno 1807 TH WB*
49.5 x 40 cm (19½ x 15¾ in)

PLATE 91
T.171-1921
French; dated 1847
Linen embroidered with silk and wool in cross stitch
Inscription: *Faite par Miete Cheilan agee de 8 ans dans la classe des
soeurs des Saints Noms de Jesus et de Marie Lancon 1847*
(Made by Miete Cheilan aged 8 years in the class of the
Sisters of the Holy Names of Jesus and of Marie Lancon
1847)
48.3 x 54.6 cm (19 x 21½ in)

PLATE 92
T.24-1916
Italian; dated 1855
Linen embroidered with silk in cross stitch
Inscription: *Vittoria Luchetti fece lanno 1855*
(Vittoria Luchetti made it in the year 1855)
19 x 33.7 cm (7½ x 13¼ in)
Given by Mrs LFM Preston

PLATE 93
Circ.551-1923
Mexican; dated 1826
Linen embroidered with silk in back, long-armed cross and
satin stitch with drawn thread work
Inscription: *Da Anastasia Anrrigues [] 1826*
(Doña Anastasia Anrrigues ... inscription unclear)
64 x 49.5 cm (25³⁄₁₆ x 19½ in)

PLATE 94
T.54-1931
Mexican; dated 1860
Linen embroidered with silk and cotton in cross, satin and
Florentine stitch with drawn thread work
Inscription: *Lo hiso Rosa Maria a Vasconcelos Agosto 23 de 1860*
(Rosa Maria a Vasconcelos made this 23 August 1860)
40 x 38.1 cm (15¾ x 15 in)
Bequeathed by AP Maudslay

PLATE 95
T.565-1919
Mexican; mid-19th century
Cotton embroidered with cotton in cross stitch
69.2 x 76.2 cm (27¼ x 30 in)

PLATE 96
234-1869
Swedish (Skania); dated 1863
Linen embroidered with silk and cotton in cross, satin and
chain stitch with cutwork and drawn thread work
Inscription: *SKA 1863*
39.4 x 38.1 cm (15½ x 15 in)
Given by Mrs Bury Palliser

PLATE 97
194-1885
German (*Gewerbeschule für Mädchen*, Hamburg); 1884
Linen embroidered with silk, with drawn thread work
42.5 x 33 cm (16¾ x 13 in)

PLATE 98
T.325-1921
Turkish; 19th century
Cotton embroidered with silk in double running stitch
48.3 x 26.7 cm (19 x 10½ in)
Given by GD Hornblower

PLATE 99
T.150-1929
Moroccan; 19th century
Cotton embroidered with silk and cotton in double running
and satin stitch
76.8 x 71.8 cm (30¼ x 28¼ in)

PLATE 100
T.35-1933
Moroccan; 19th century
Cotton embroidered with silk in double running, back, cross,
long-armed cross and satin stitch
103 x 73.5 cm (40½ x 29 in)
Given by GD Pratt

PLATE 101
Pattern darning; detail of plate 67

PLATE 102
Double running stitch; detail of plate 17

PLATE 103
Tent stitch; detail of plate 11

PLATE 104
The use of texture; detail of plate 11

PLATE 105
The use of texture; detail of plate 34

PLATE 106
Satin stitch and pulled thread work; detail of plate 37

PLATE 107
Pulled thread work; detail of plate 64

PLATE 108
Drawn thread work; detail of plate 20

PLATE 109
Cutwork; detail of plate 36

PLATE 110
Cutwork with detached buttonhole stitch; detail of plate 22

PLATE 111
Cutwork with hollie stitch; detail of plate 47

PLATE 112
Double running stitch; detail of the back of plate 28

The Plates

PLATE 1
Egyptian (Mamluk);
14th to 16th century
T.326-1921

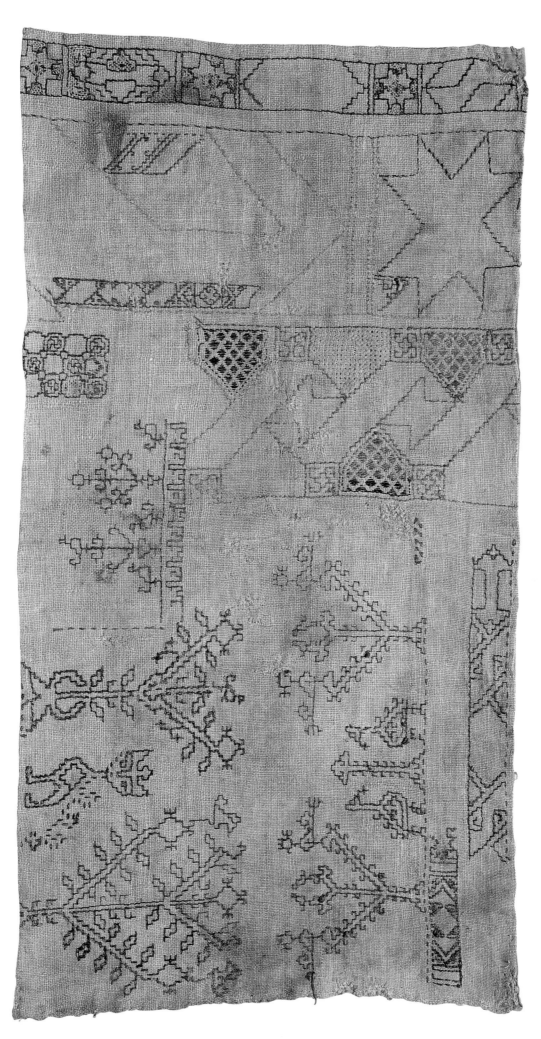

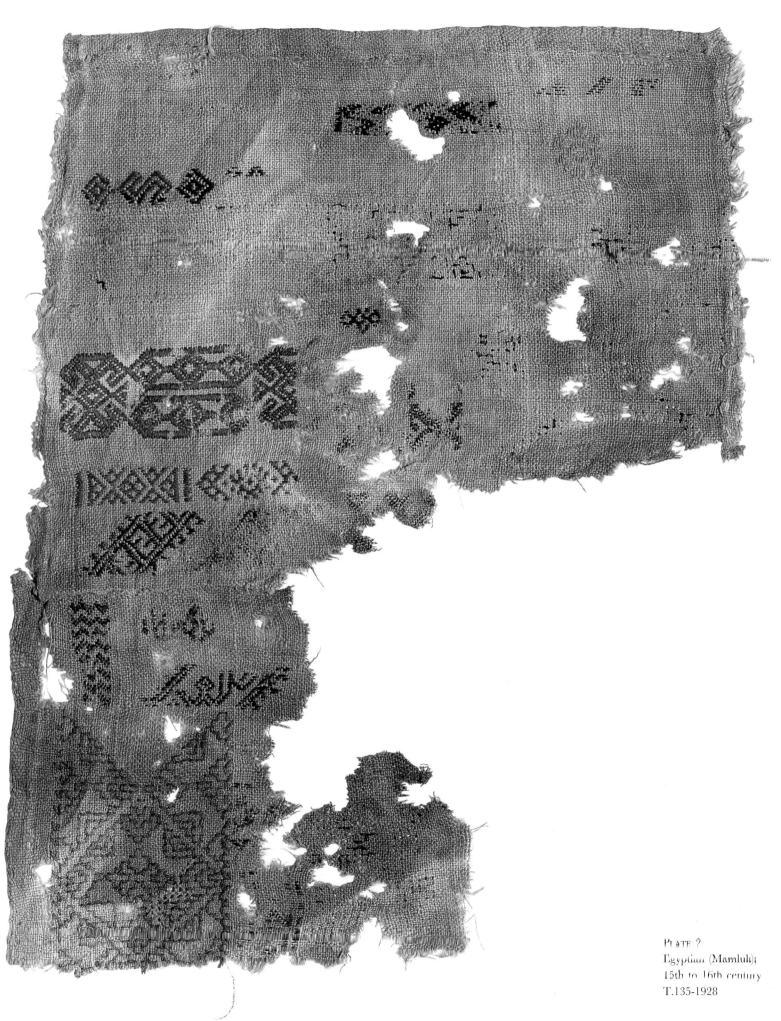

Plate 2
Egyptian (Mamluk);
15th to 16th century
T.135-1928

27

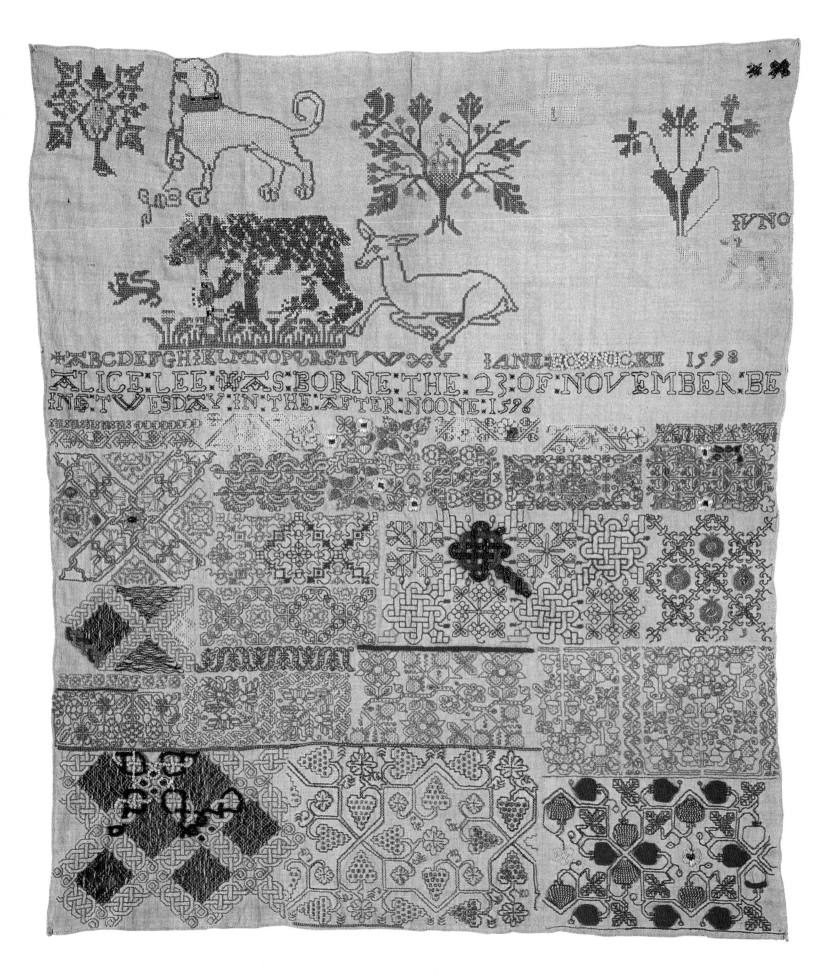

PLATE 3
English; 1598
T.190-1960

28

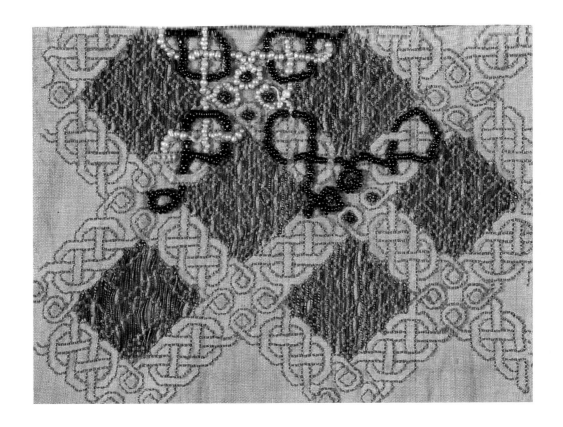

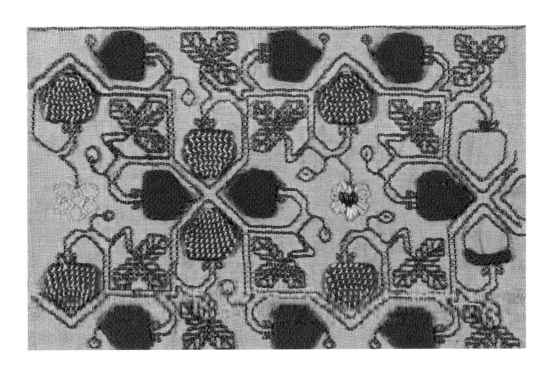

PLATE 3
Details

Plate 4
German; first half
16th century
T.114-1956

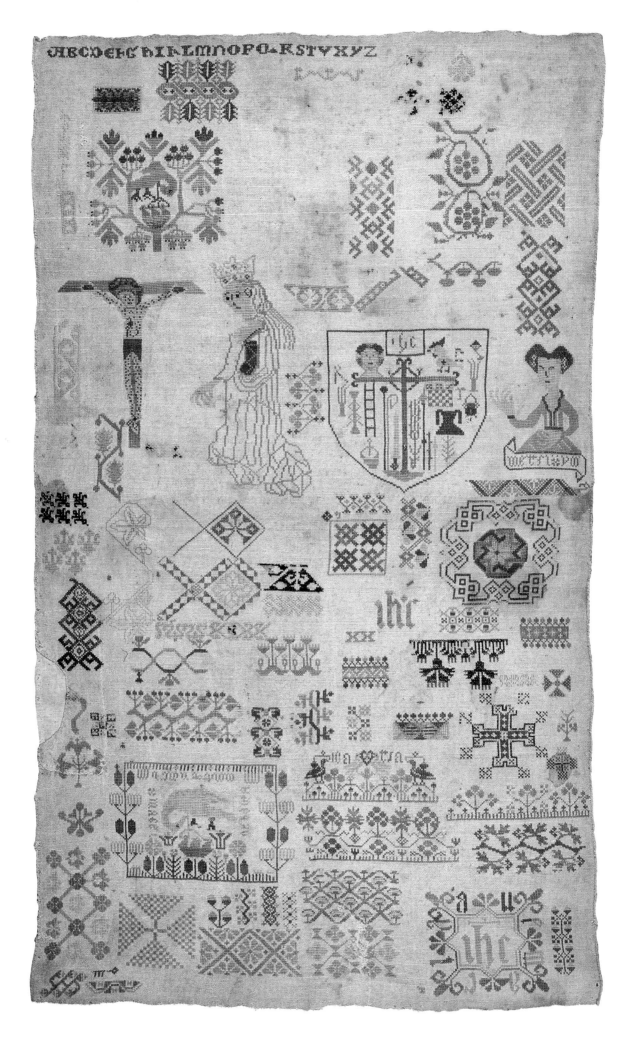

PLATE 4
Detail

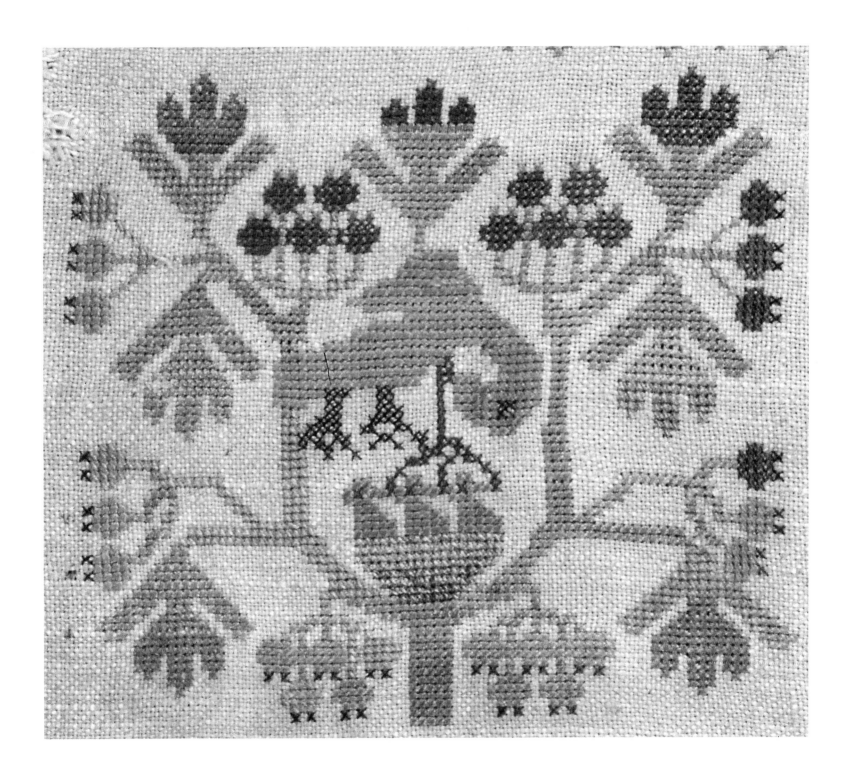

PLATE 5
Italian: 16th century
T.14-1931

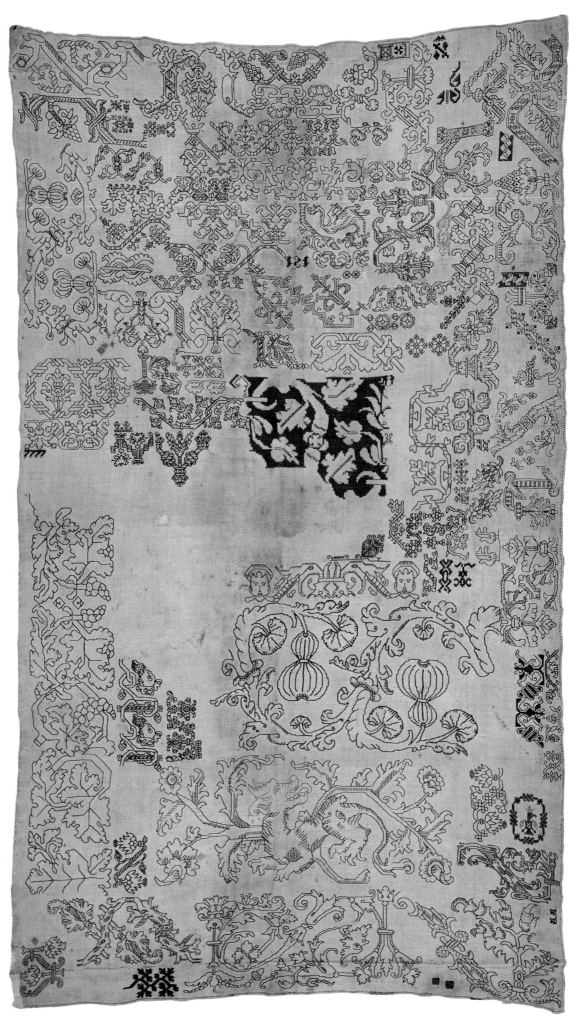

PLATE 5
Details

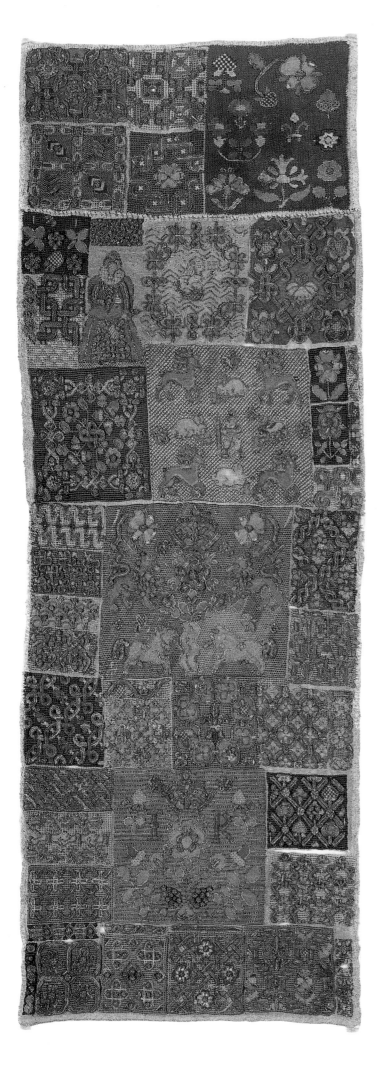

PLATE 6
English; first quarter
17th century
9047-1863

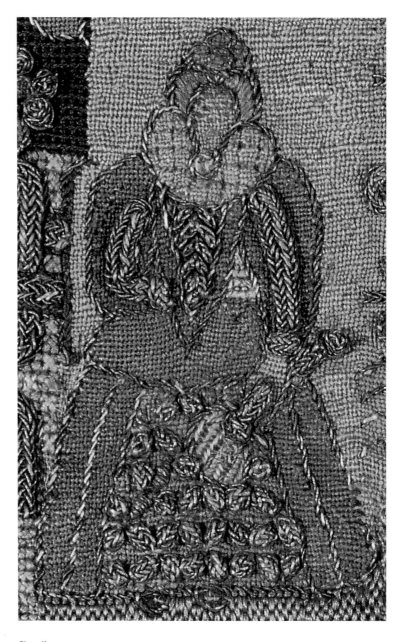

Detail

34

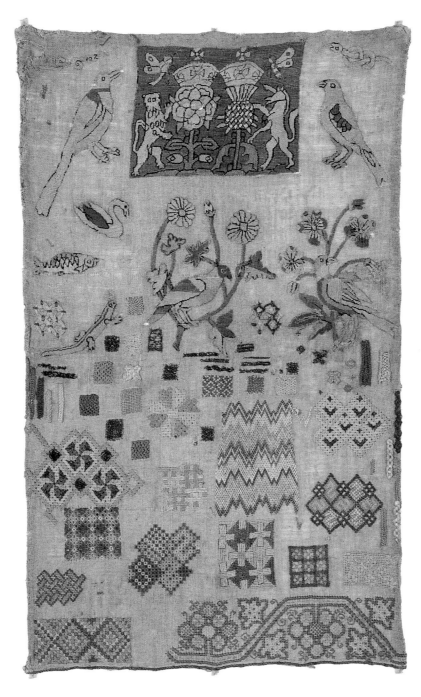

PLATE 7
English; second
quarter 17th century
Circ.279-1923

Detail

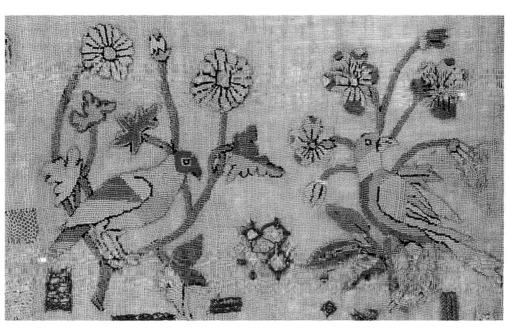

PLATE 8
English; first half
17th century
T.20-1913

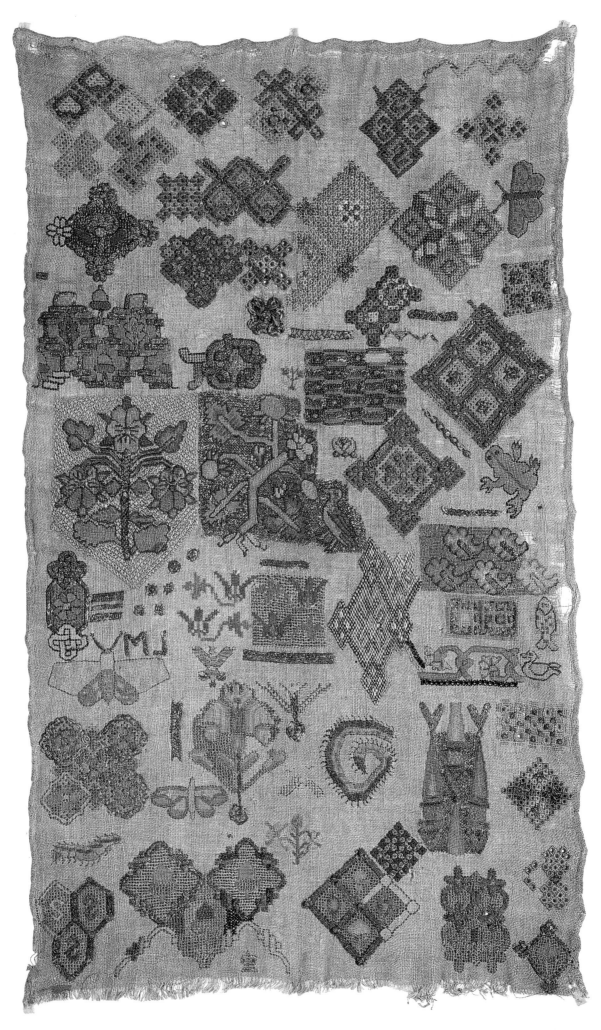

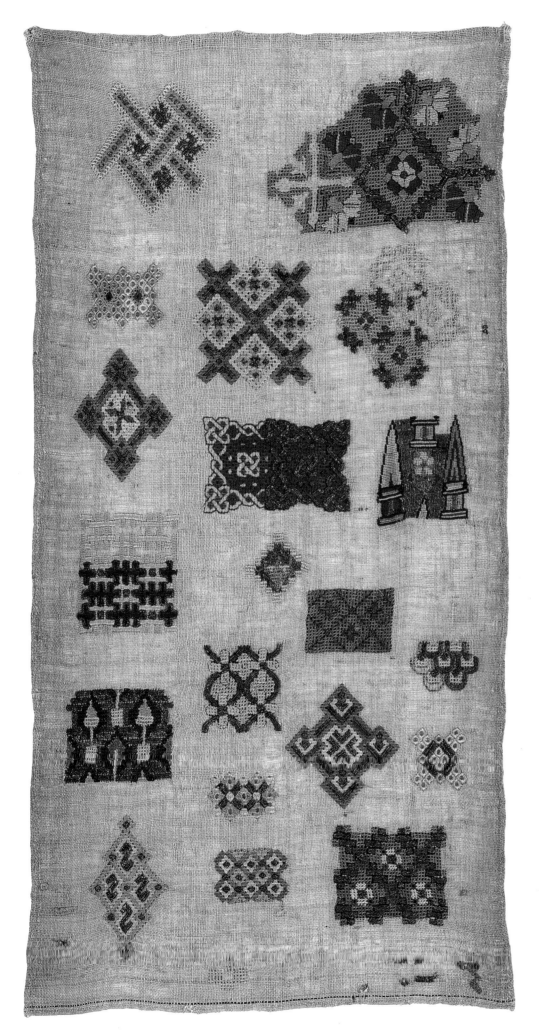

PLATE 9
English; first half
17th century
T.80-1918

Detail

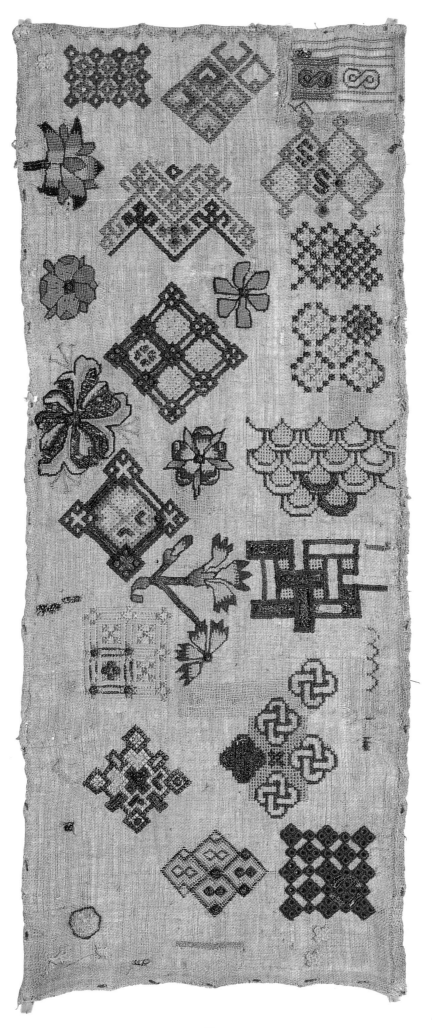

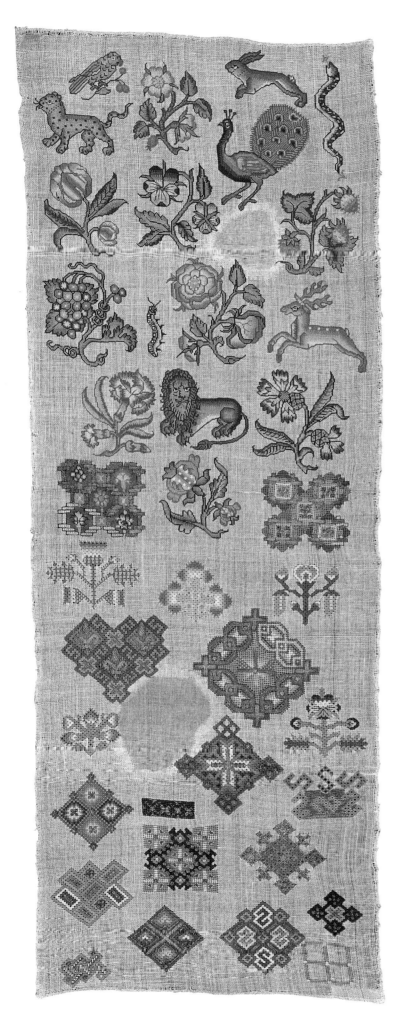

PLATE 11
English;
mid-17th century
T.234-1928

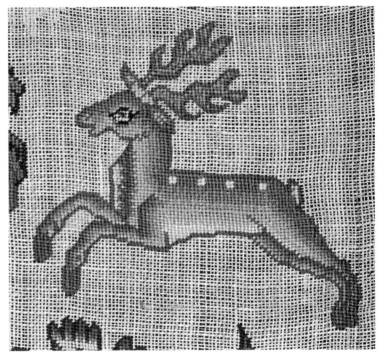

Detail

39

PLATE 12
English;
mid-17th century
T.40-1955

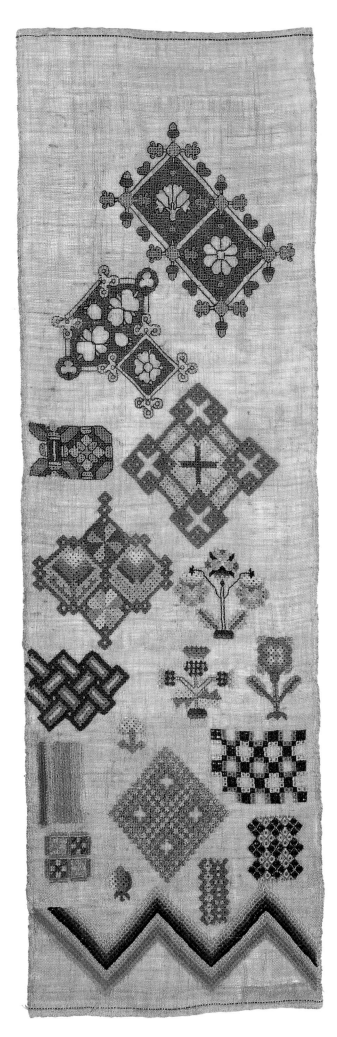

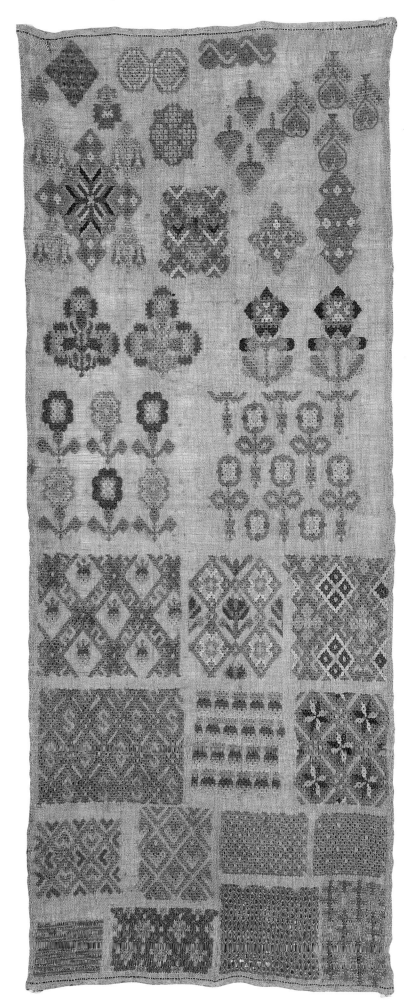

PLATE 13
English;
mid-17th century
T.262-1927

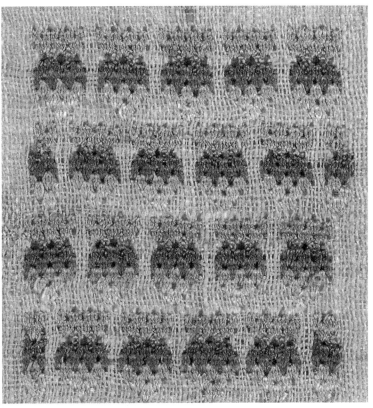

Detail

Plate 14
English; first half
17th century
T.230-1929

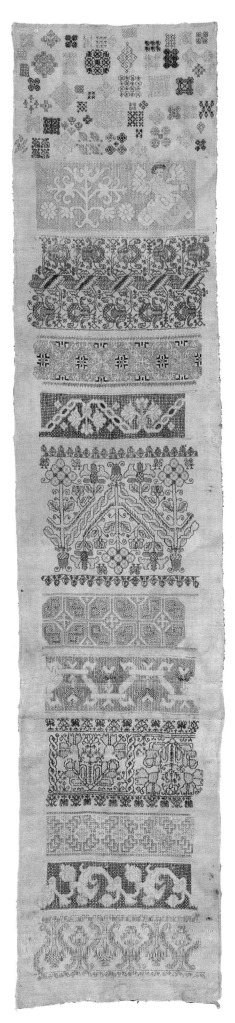

PLATE 15
English; first half
17th century
516&A-1877

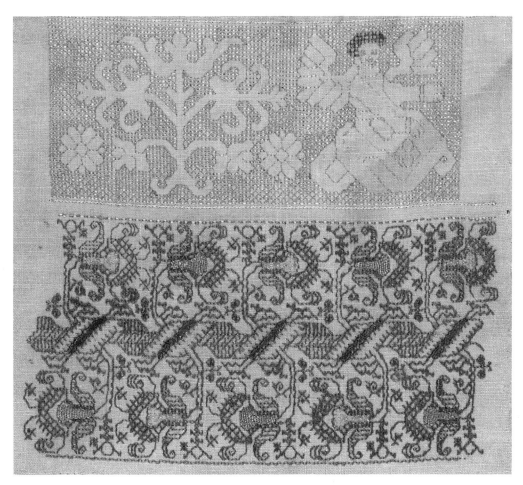

Detail

43

PLATE 16
English; dated 1633
T.194-1927

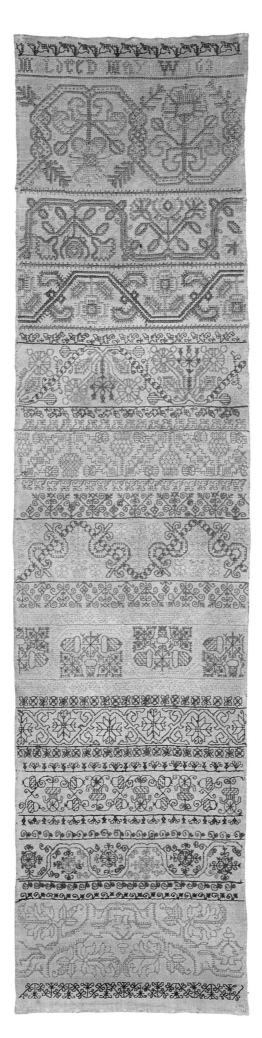

PLATE 17
English;
mid-17th century
739-1899

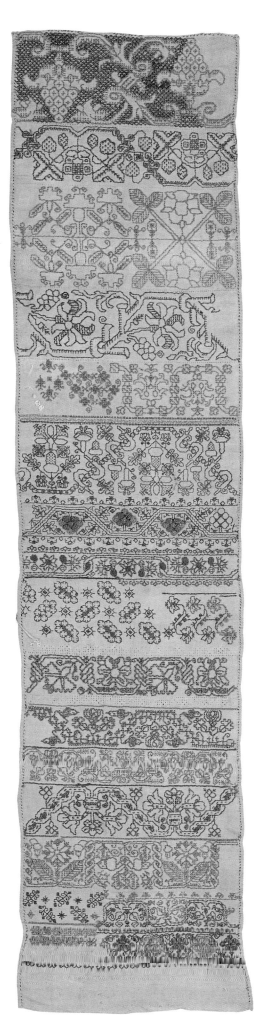

PLATE 18
English;
mid-17th century
T.185-1987

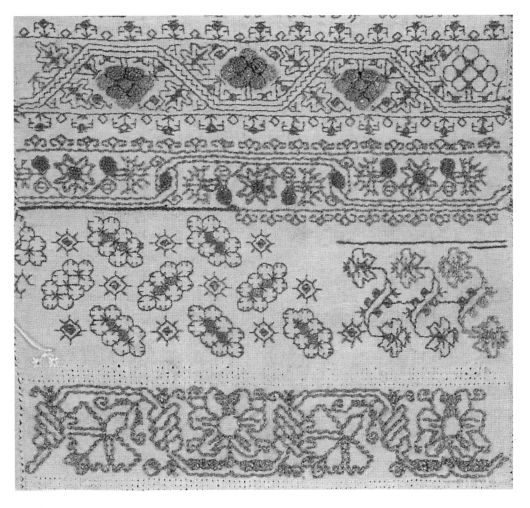

Detail

45

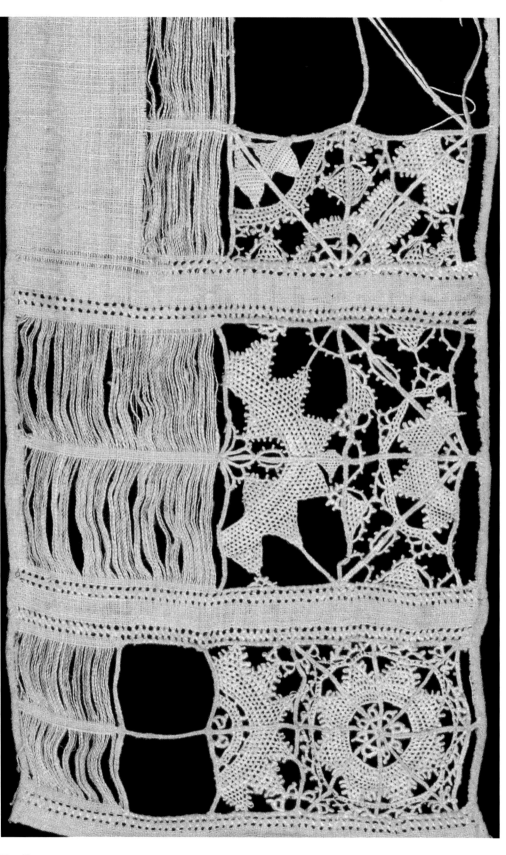

PLATE 19
English;
mid-17th century
T.184-1987

Detail

46

PLATE 20
English;
mid-17th century
T.187-1987

47

PLATE 21
English; dated 1647
Circ.110-1909

Detail

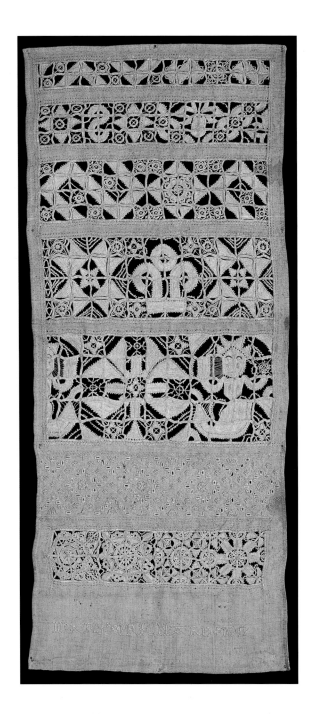

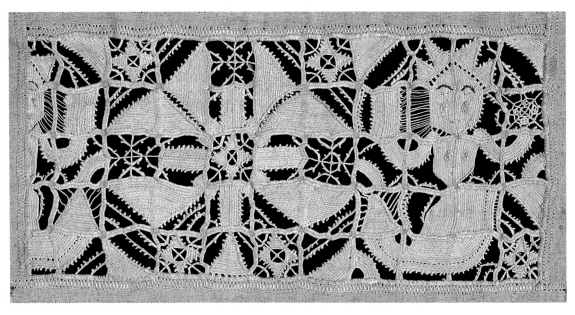

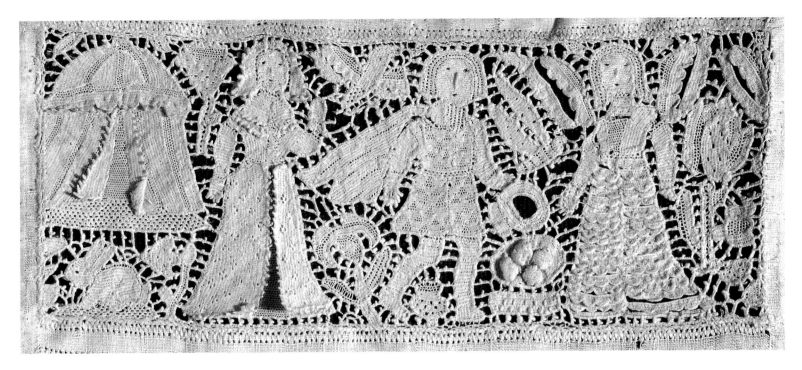

Detail

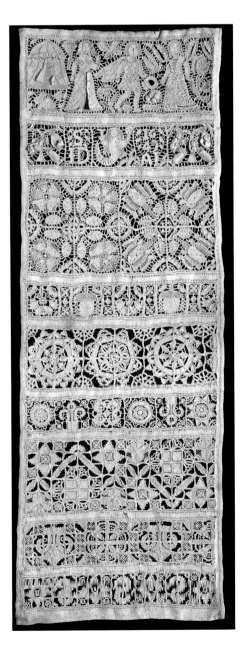

Plate 22
English; dated 1649
T.115-1956

49

PLATE 23
English;
mid-17th century
269-1898

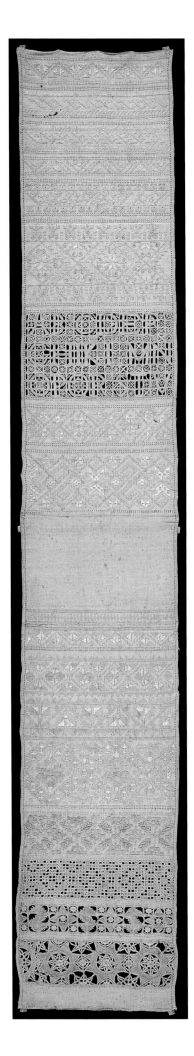

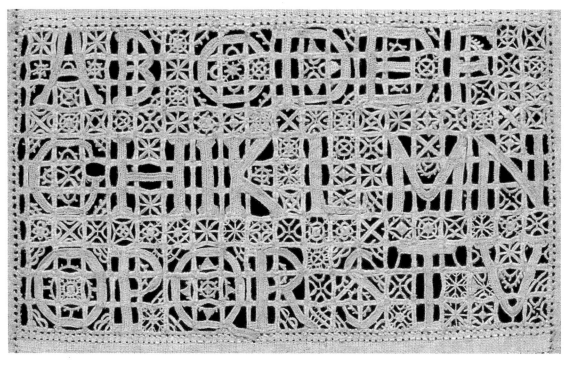

Detail

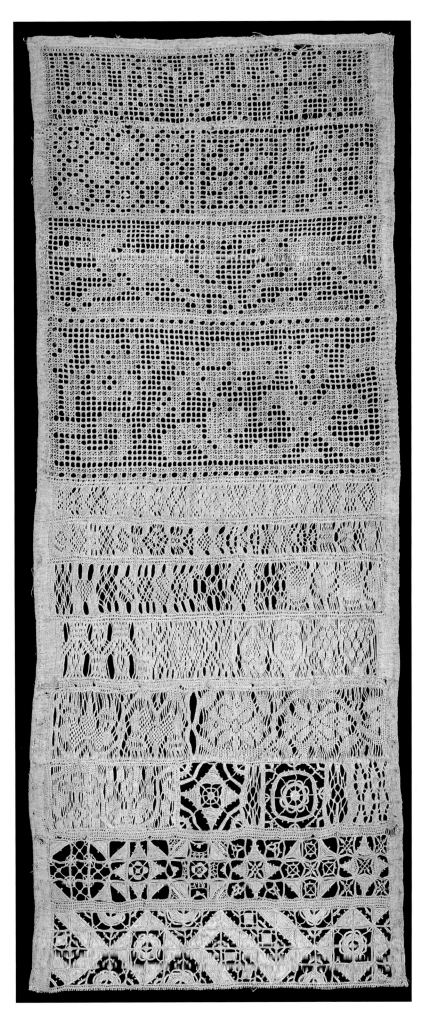

PLATE 24
English; first half
17th century
742-1899

PLATE 25
English; dated 1660
T.182-1987

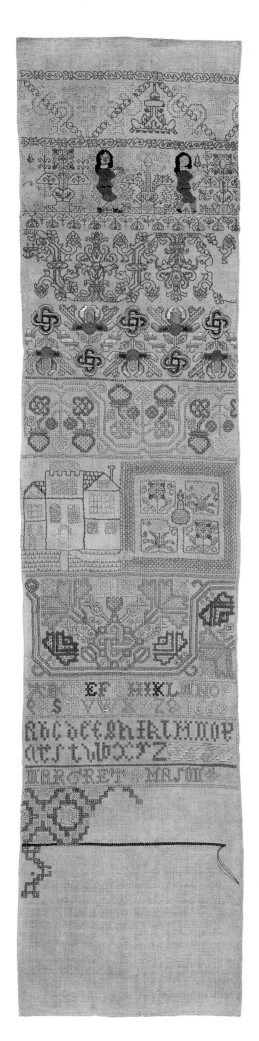

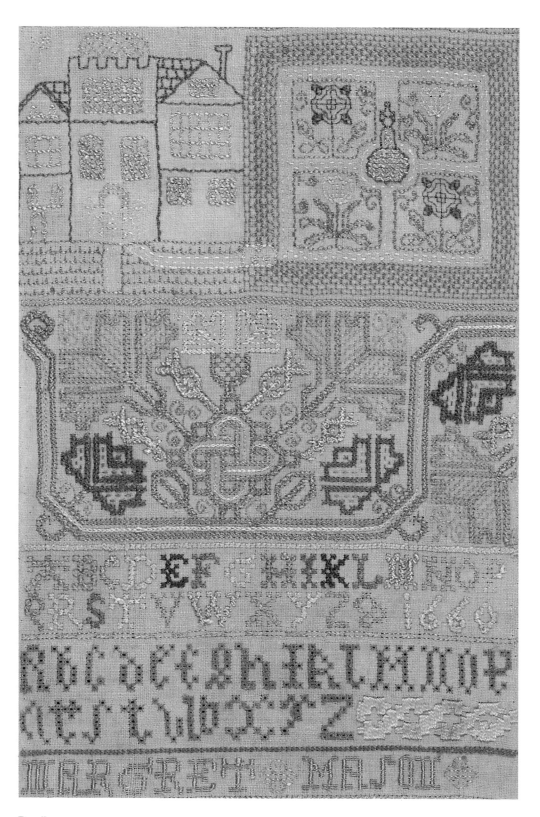

Detail

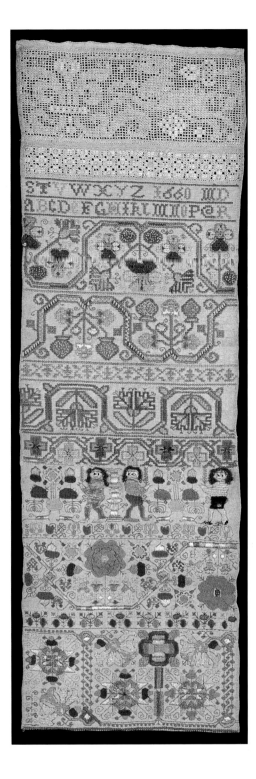

PLATE 26
English; dated 1660
T.217-1970

Detail

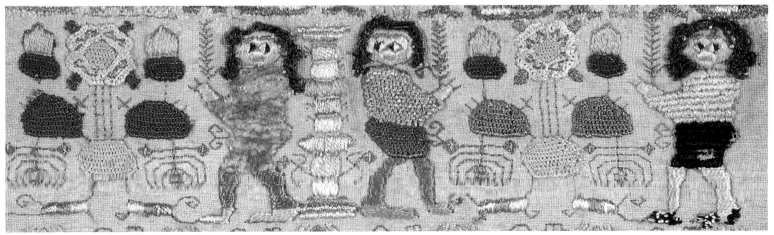

PLATE 27
English; second half
17th century
480-1894

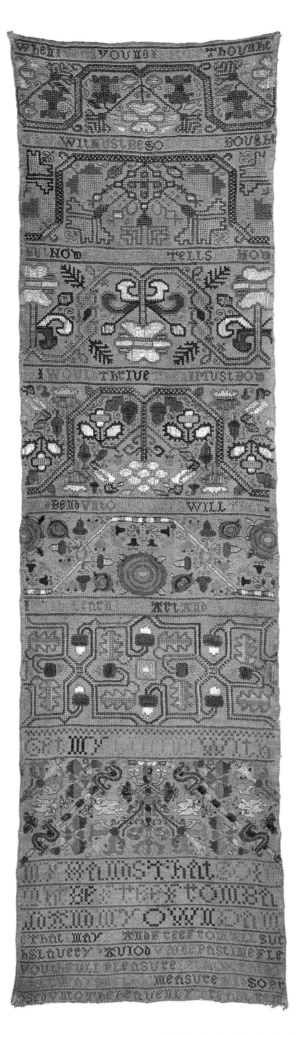

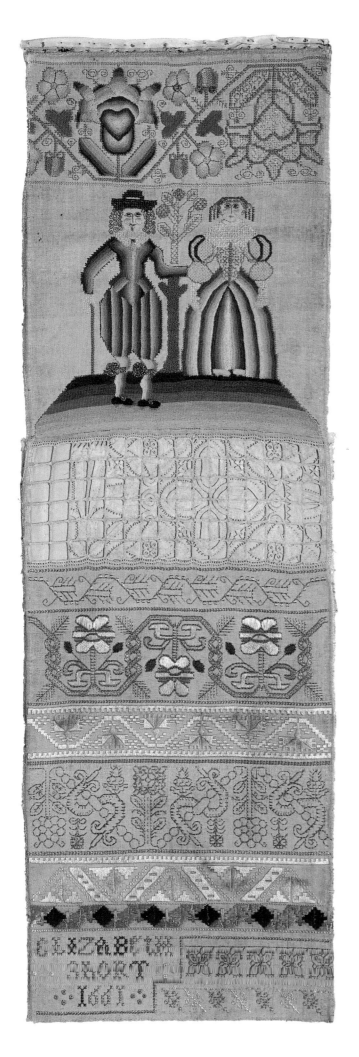

PLATE 28
English; dated 1661
T.131-1961

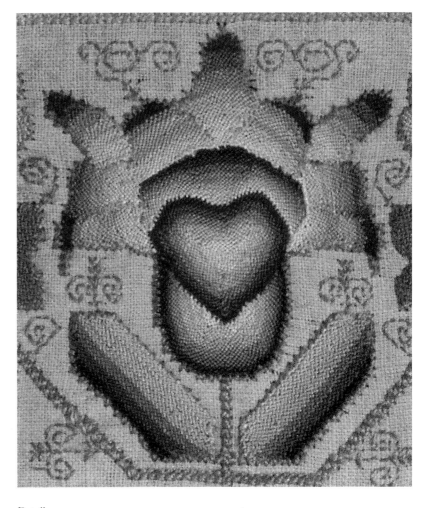

Detail

PLATE 29
English; dated 1664
570-1898

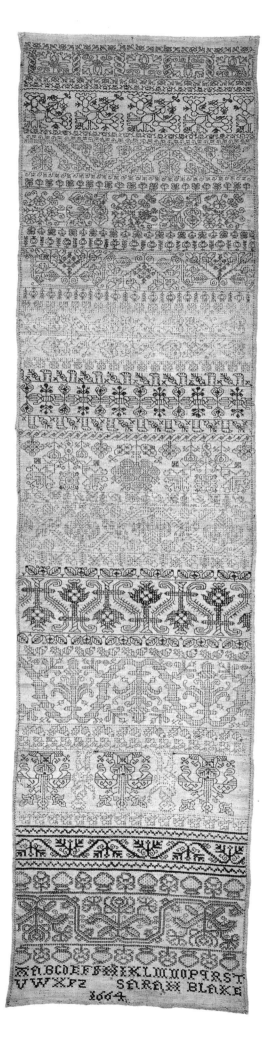

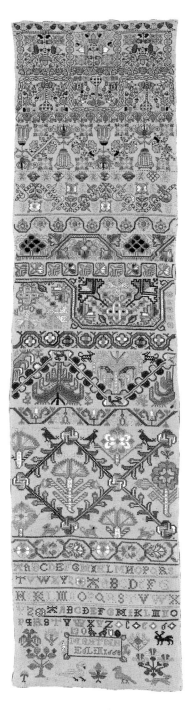

PLATE 30
English; dated 1668
T.433-1990

Detail

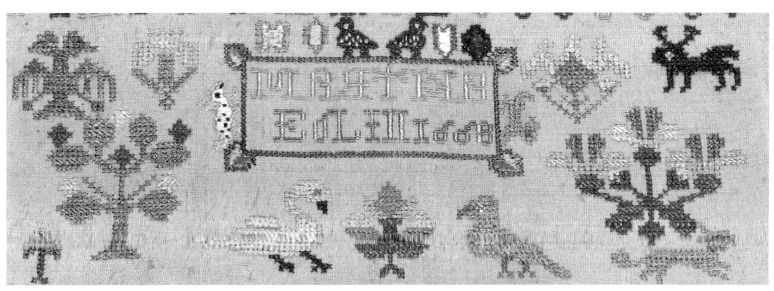

57

PLATE 31
English; dated 1669
T.434-1990

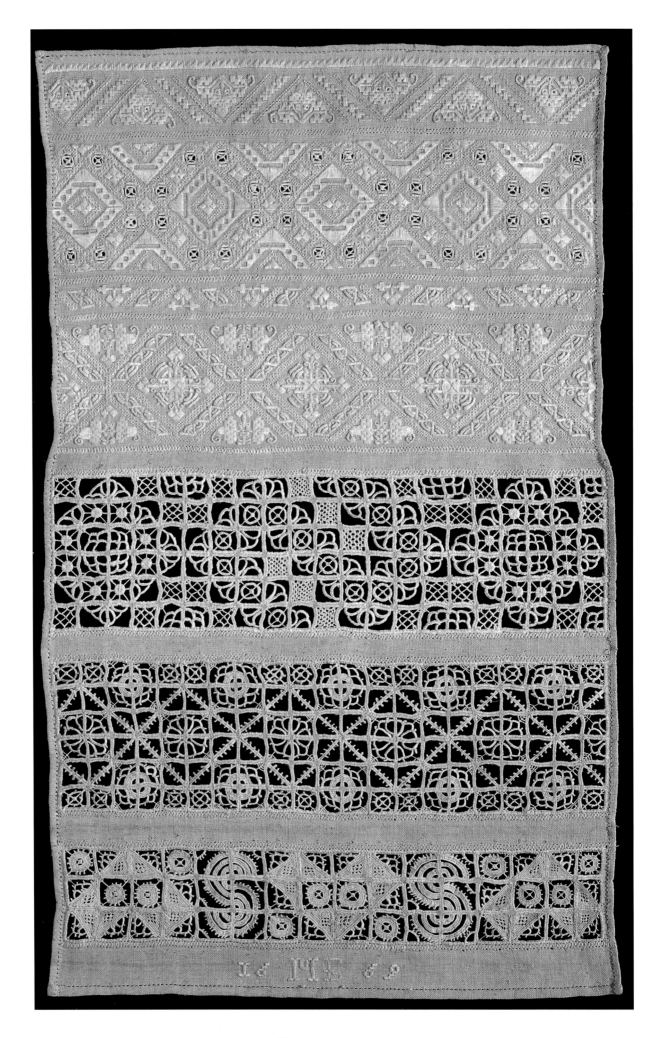

PLATE 32
English; dated 1678
T.124-1992

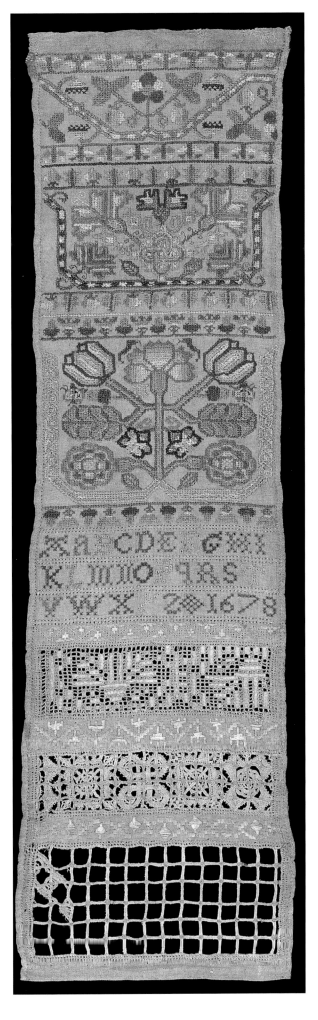

PLATE 33
English; dated 1681
T.214-1911

PLATE 34
English; dated 1696
433-1884

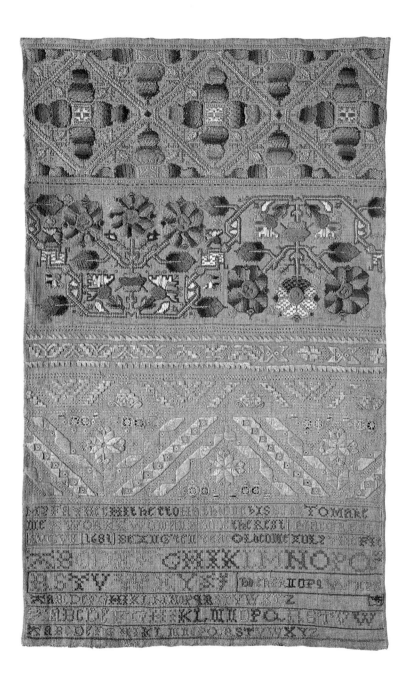

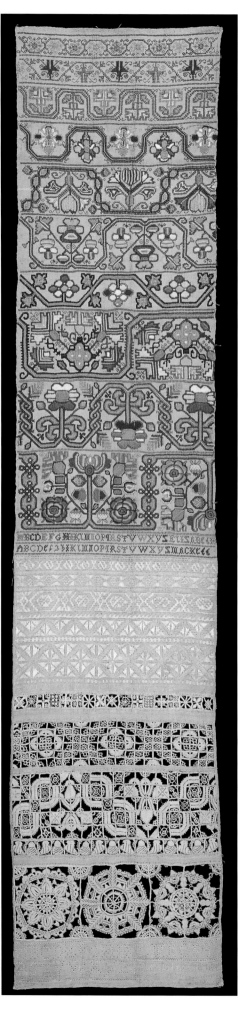

Plate 35
Italian; first half
17th century
T.126-1992

PLATE 36
Italian; first half
17th century
T.787-1919

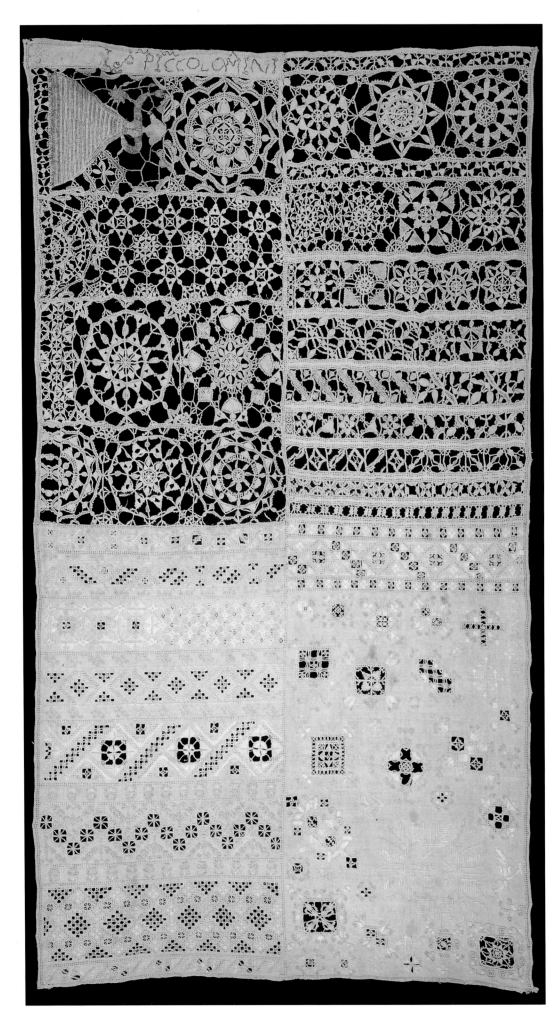

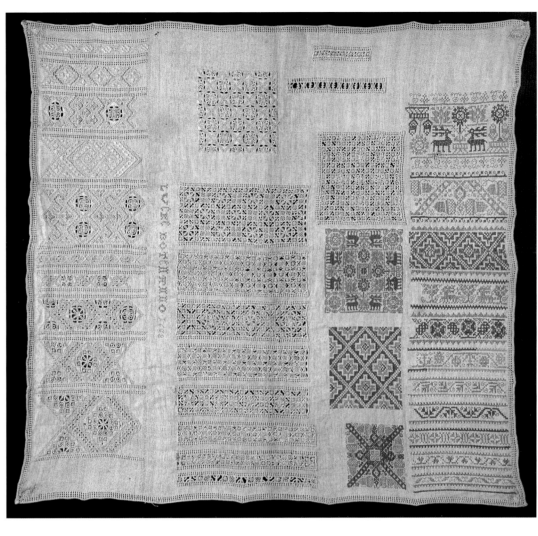

PLATE 37
German; dated 1618
T.41-1951

Detail

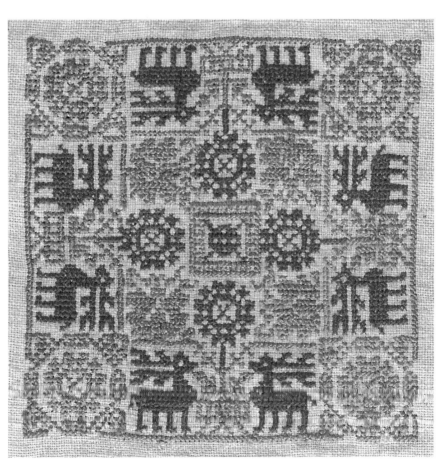

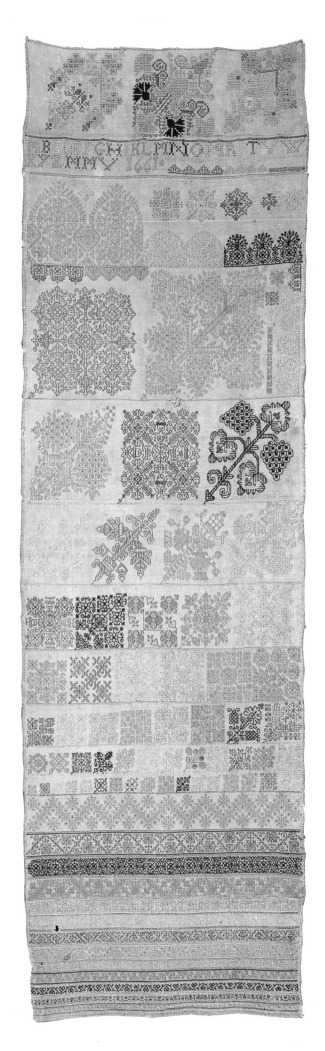

PLATE 38
German; dated 1661
368-1907

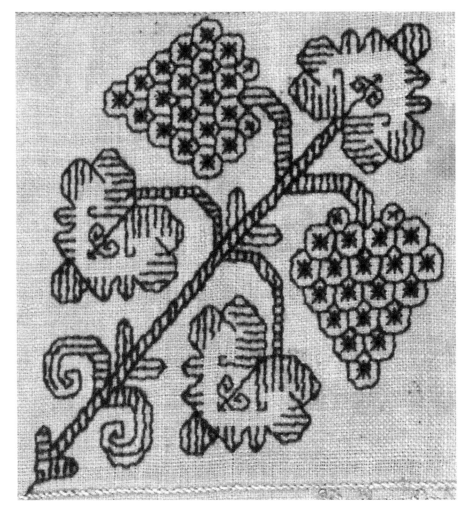

Detail

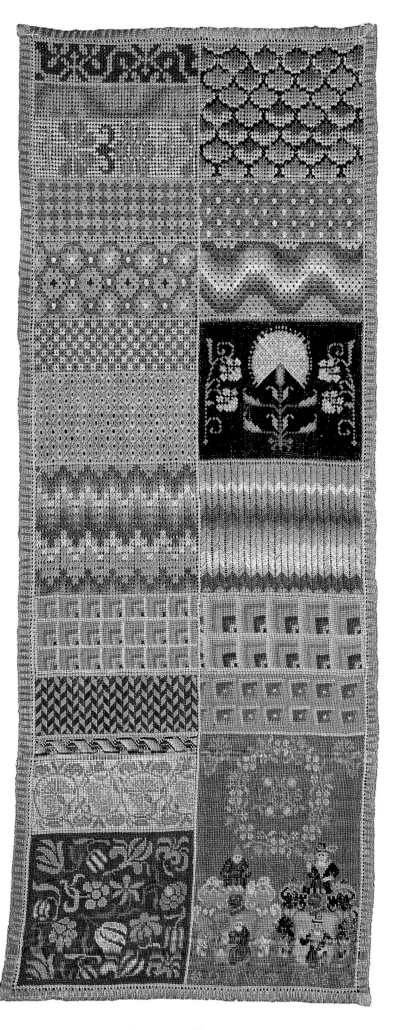

PLATE 39
German; dated 1688
104-1880

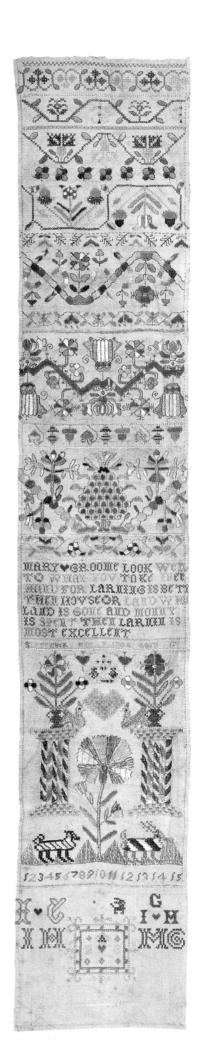

PLATE 40
English; dated 1704
T.125-1992

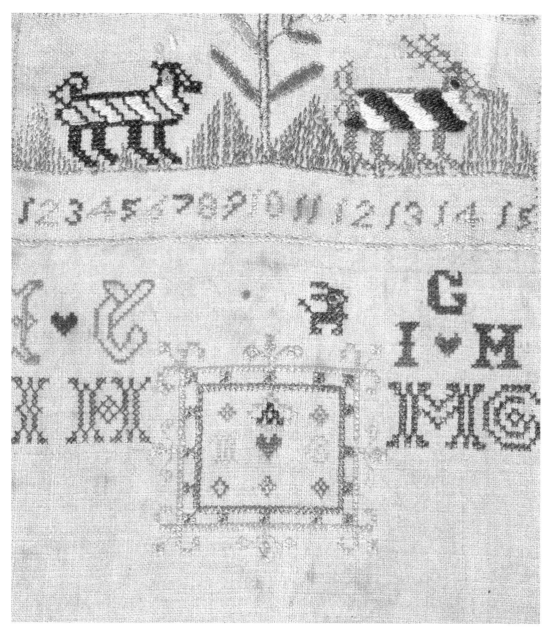

Detail

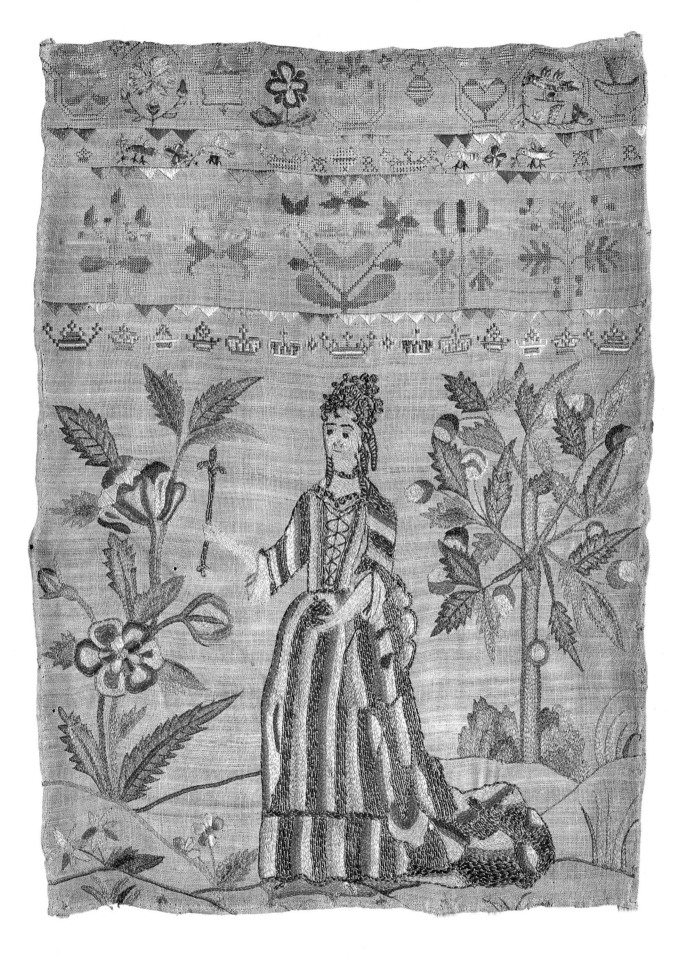

PLATE 41
English; early 18th century
T.77-1916

PLATE 42
English; dated 1710
145-1907

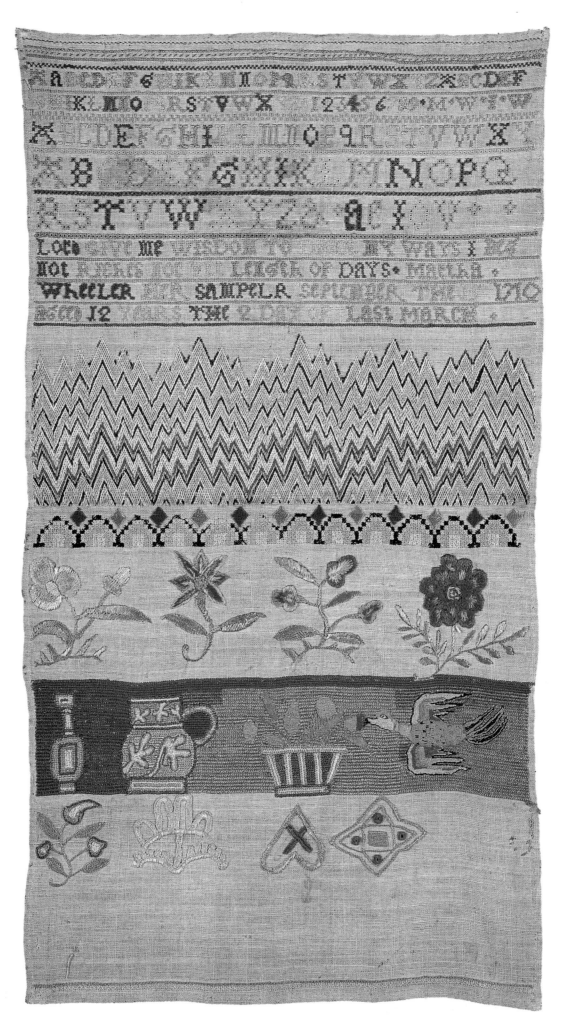

PLATE 43
English;
dated 1719
T.22-1955

PLATE 44
English; dated 1729
T.291-1916

Detail

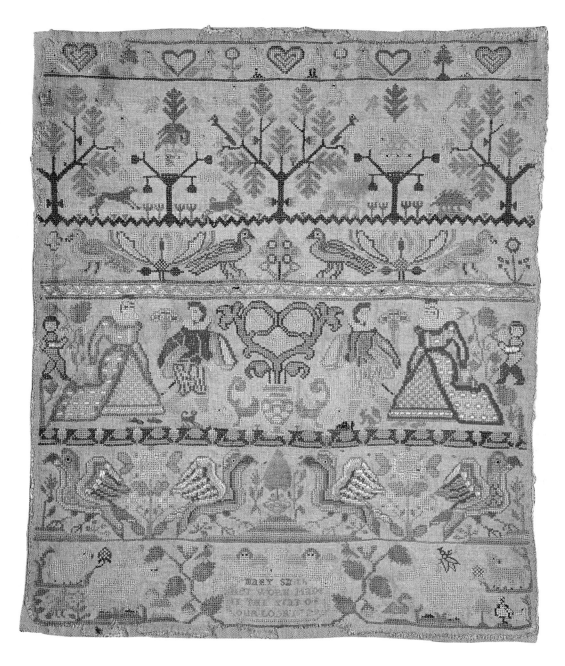

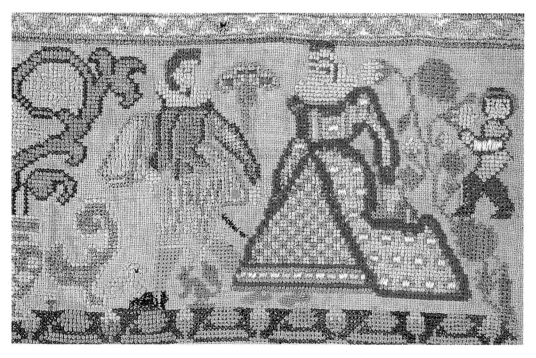

PLATE 45
English; dated 1737
T.318-1960

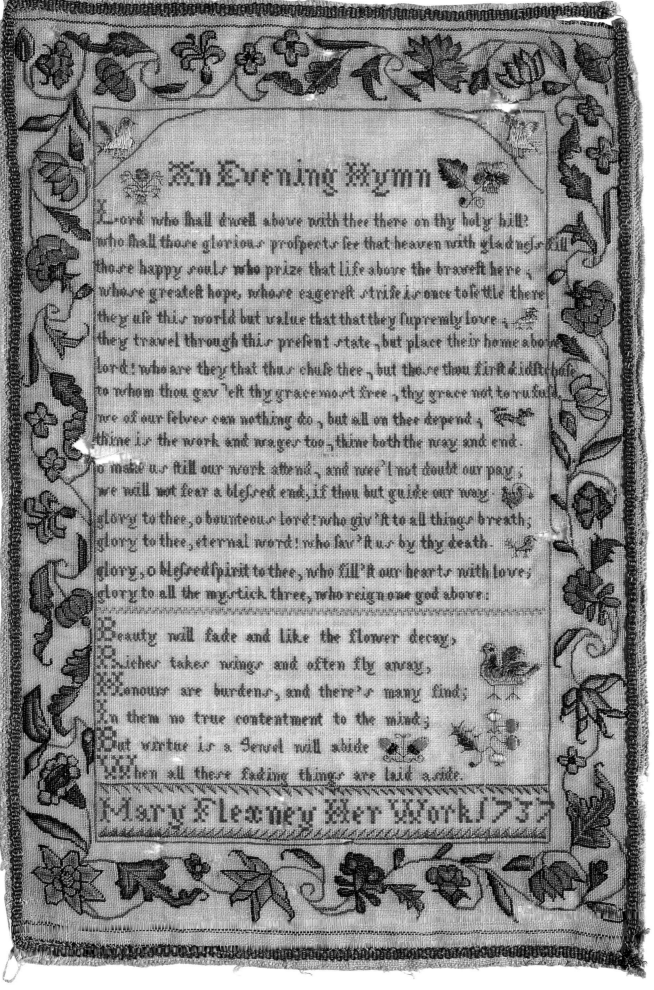

PLATE 46
English; second
quarter 18th century
T.57-1922

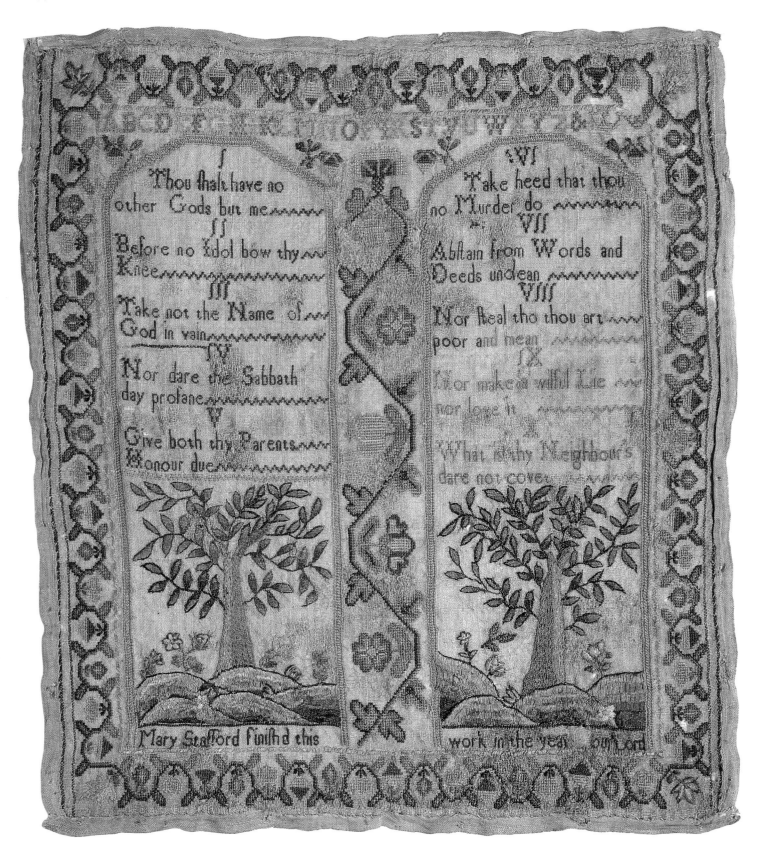

PLATE 47
English; dated 1739
T.608-1974

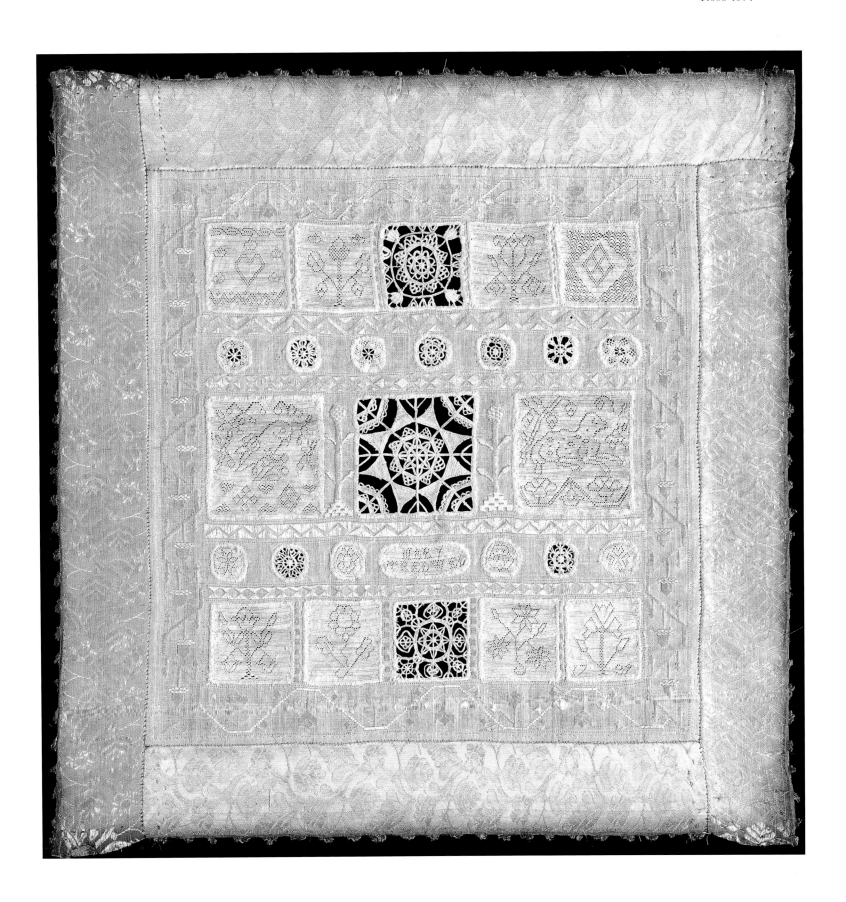

PLATE 48
English; second
quarter 18th century
T.22-1944

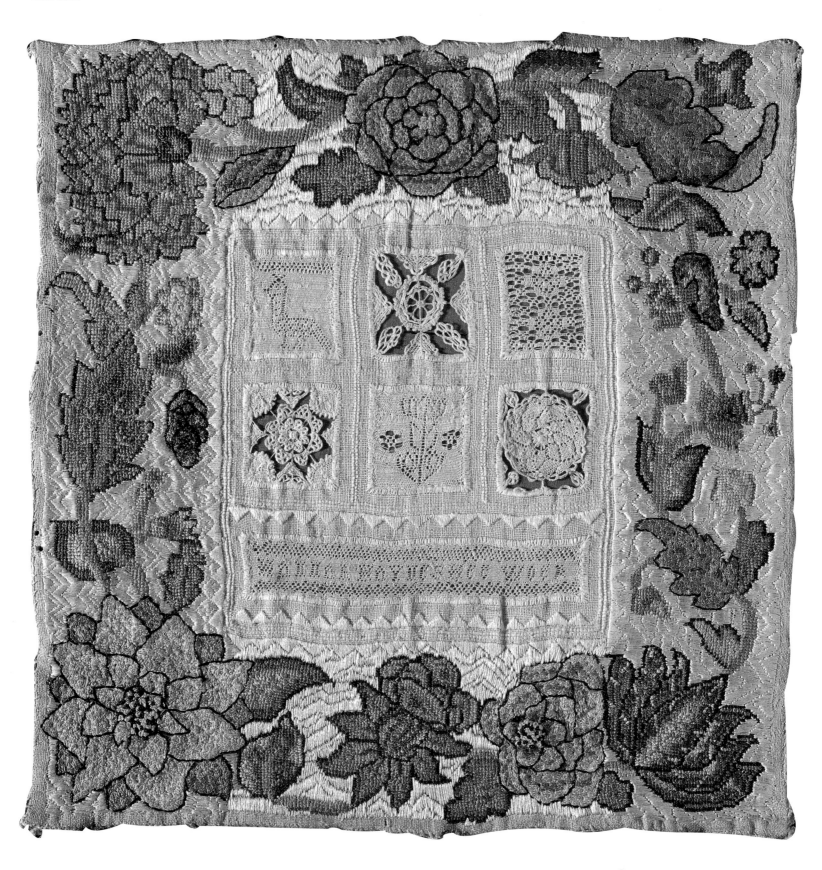

PLATE 49
English; dated 1742
394-1878

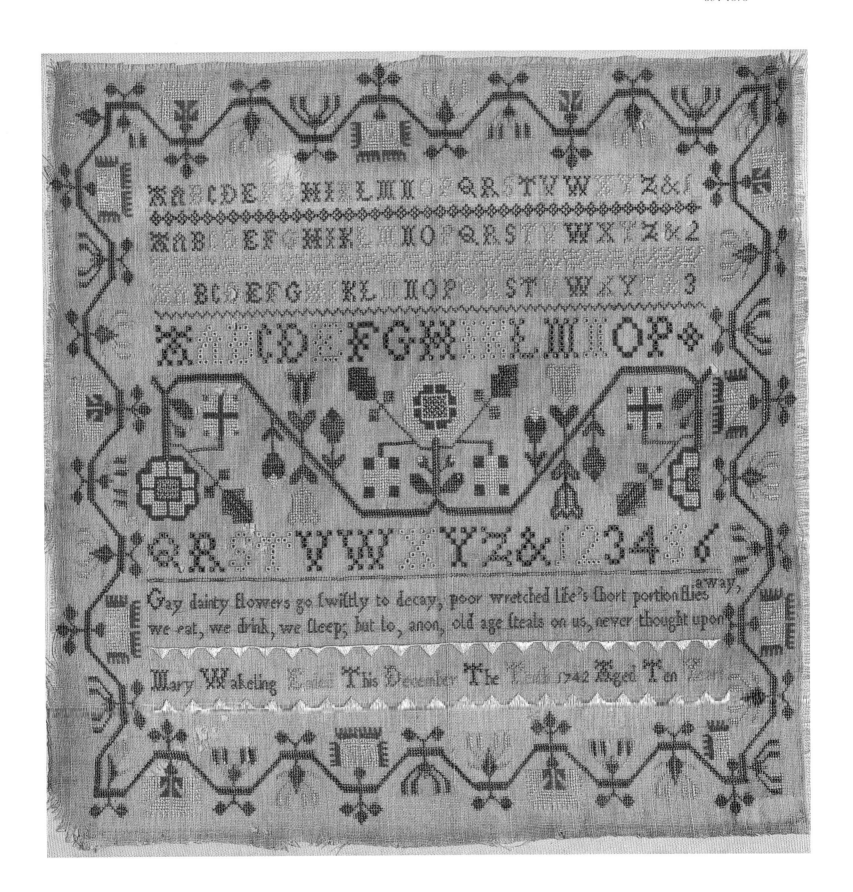

PLATE 50
Scottish or English;
dated 1749
T.205-1929

Detail

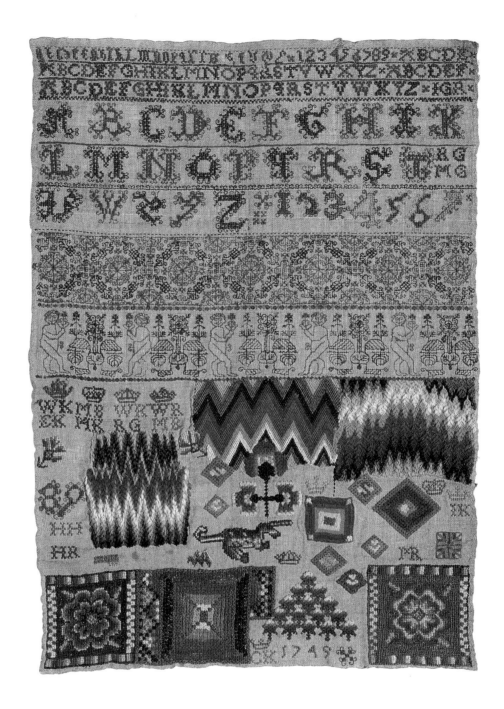

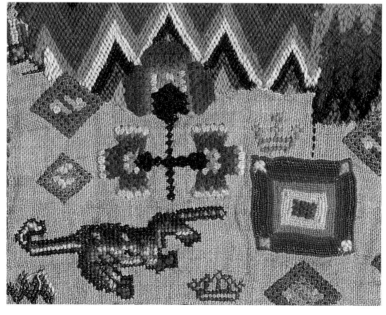

76

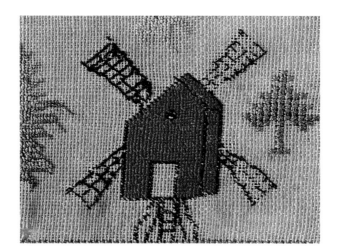

PLATE 51
English; dated 1752
288-1886

Detail

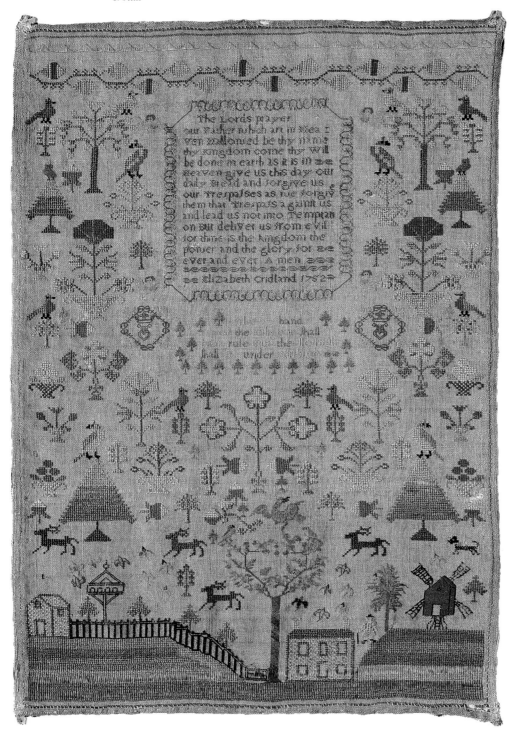

PLATE 52
English; dated 1780
T.46-1970

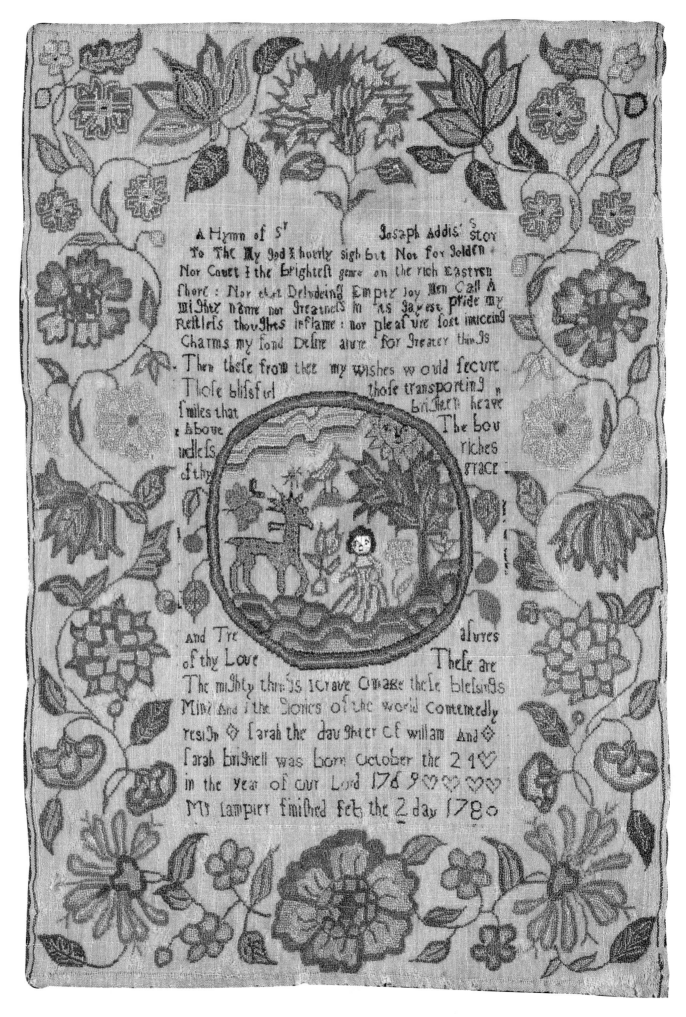

PLATE 53
English; dated 1784
T.56-1948

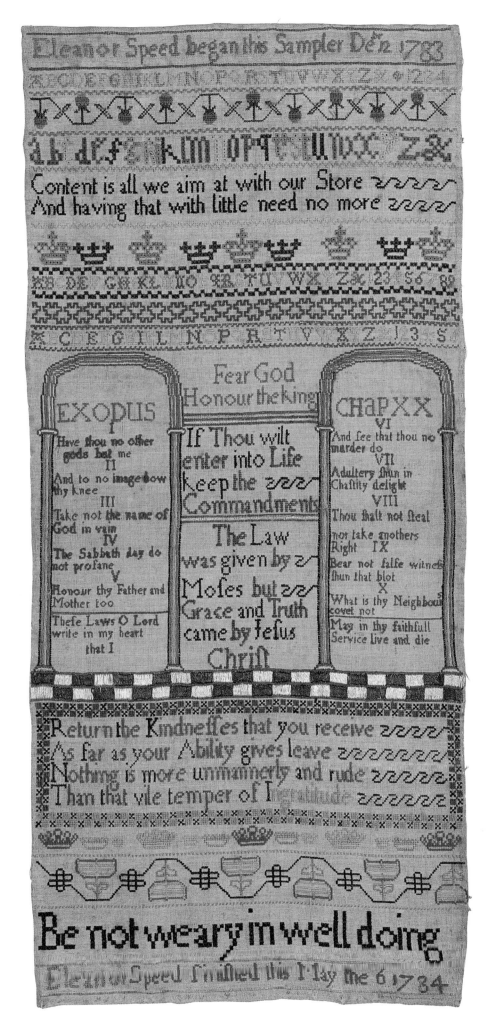

PLATE 54
English; late
18th century
T.36-1945

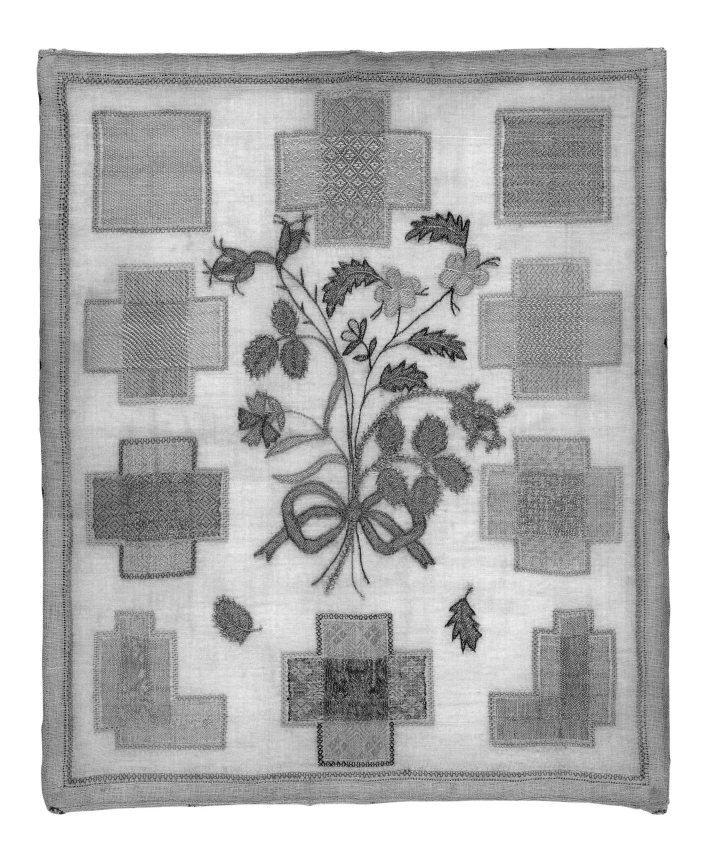

PLATE 55
English; dated 1785
T.731-1997

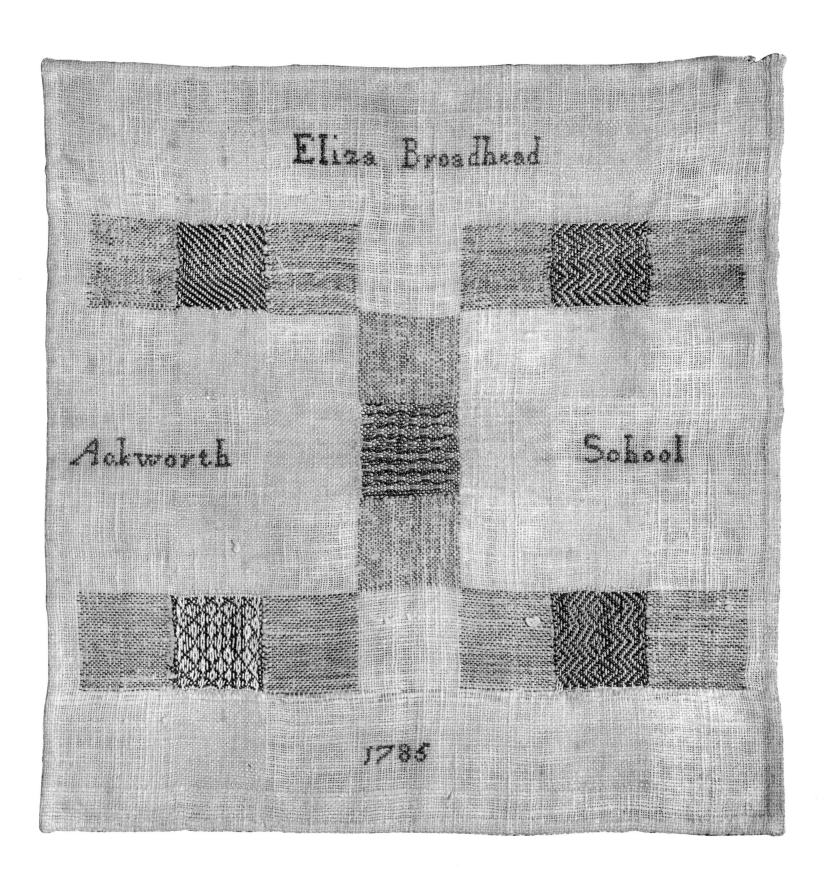

Plate 56
English; dated 1785
T.750-1974

Plate 57 (opposite)
English; dated 1787
T.75-1925

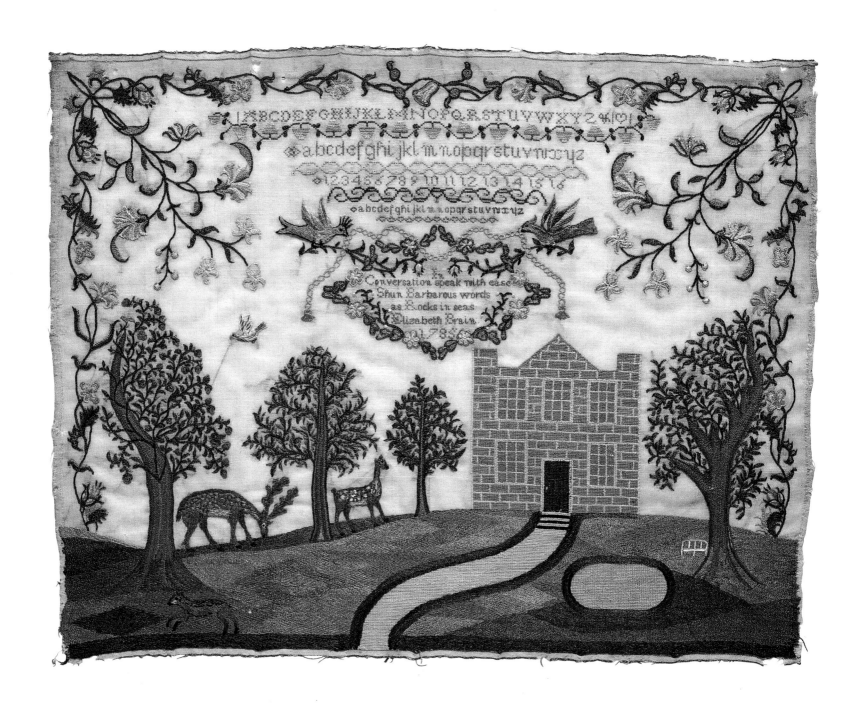

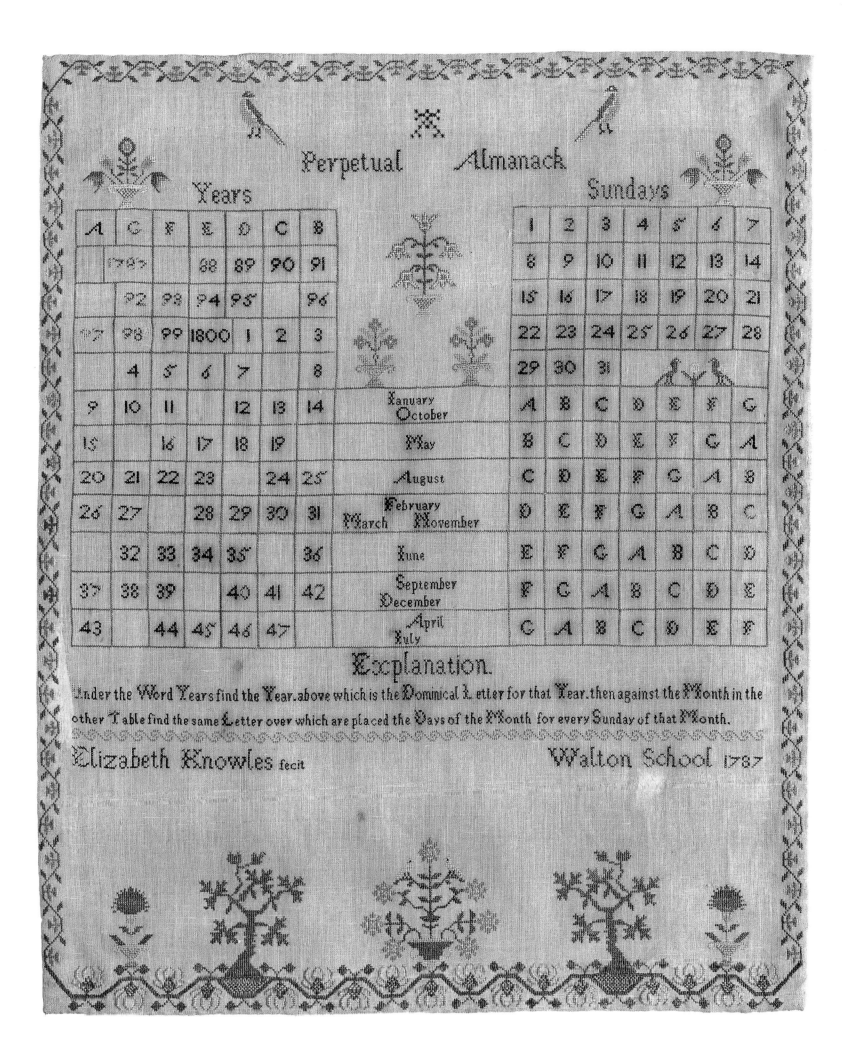

PLATE 58
English; dated 1789
T.292-1916

Detail

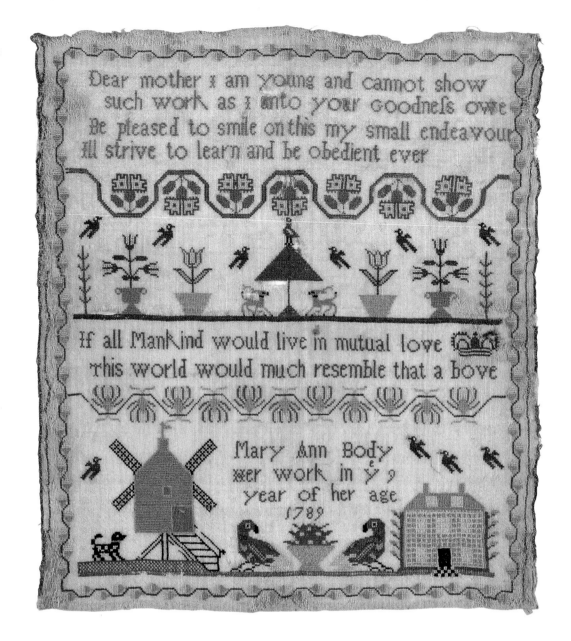

Dear mother i am young and cannot show
such work as i into your goodnefs owe
Be pleased to smile on this my small endeavour
ill strive to learn and be obedient ever

If all Mankind would live in mutual love
this world would much resemble that above

Mary Ann Body
wer work in y⁹
year of her age
1789

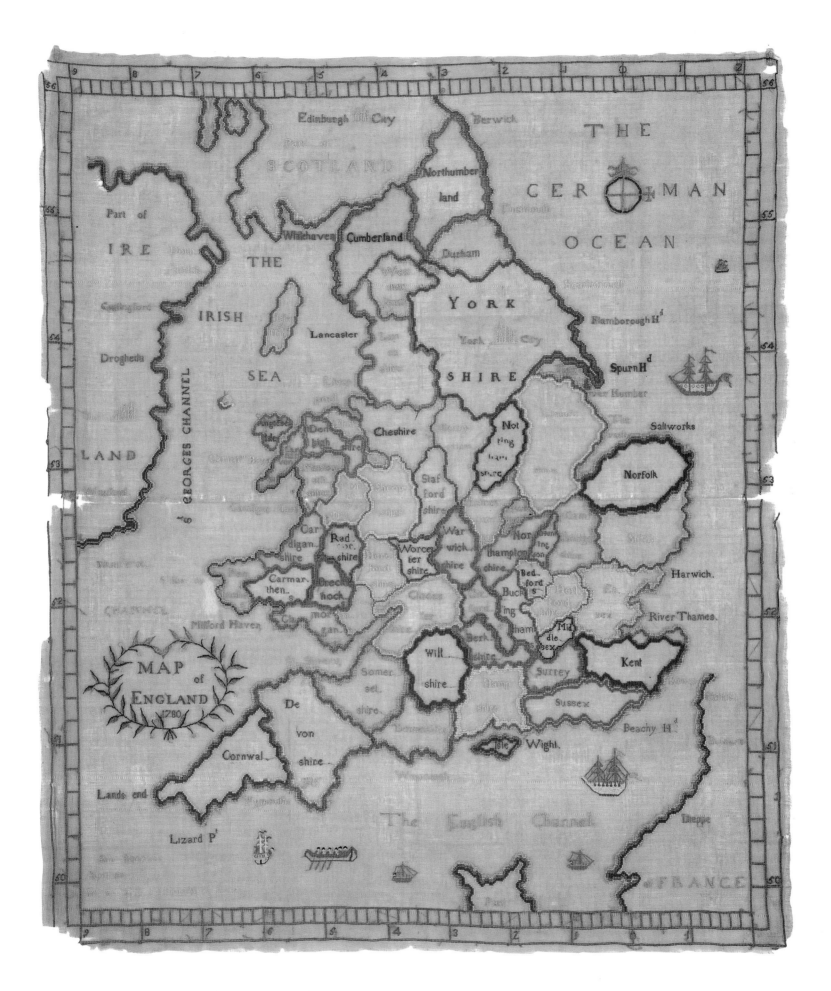

MAP of ENGLAND 1780

PLATE 59
English; dated 1780
497-1905

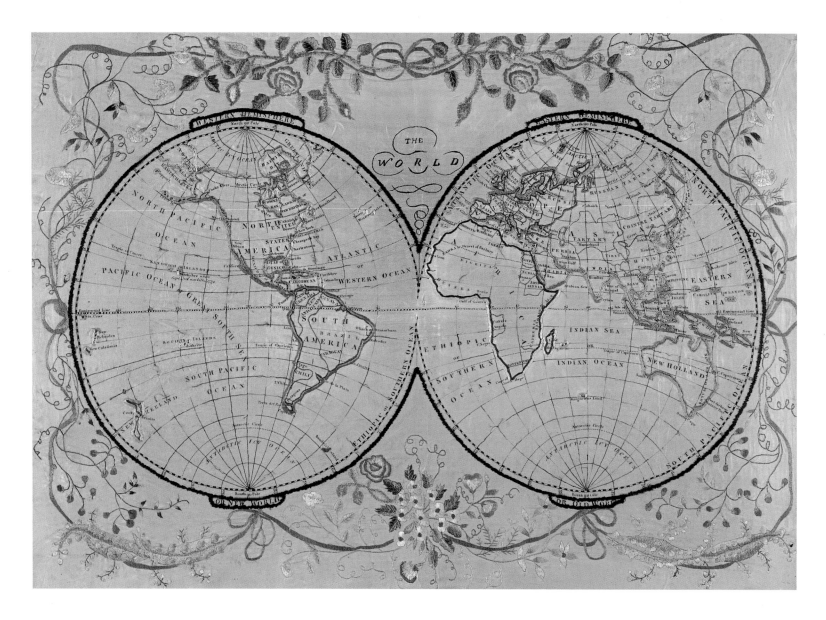

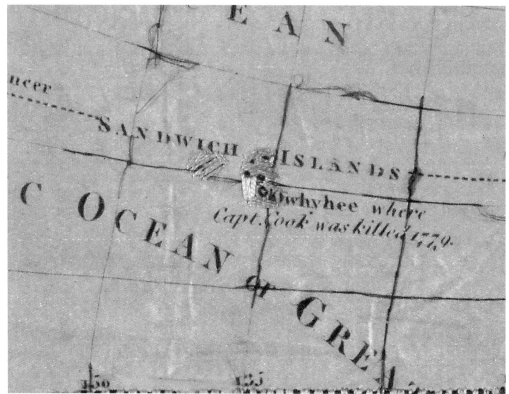

Plate 60
English; late
18th century
T.44-1951

Detail

PLATE 61
English; dated 1797
T.165-1959

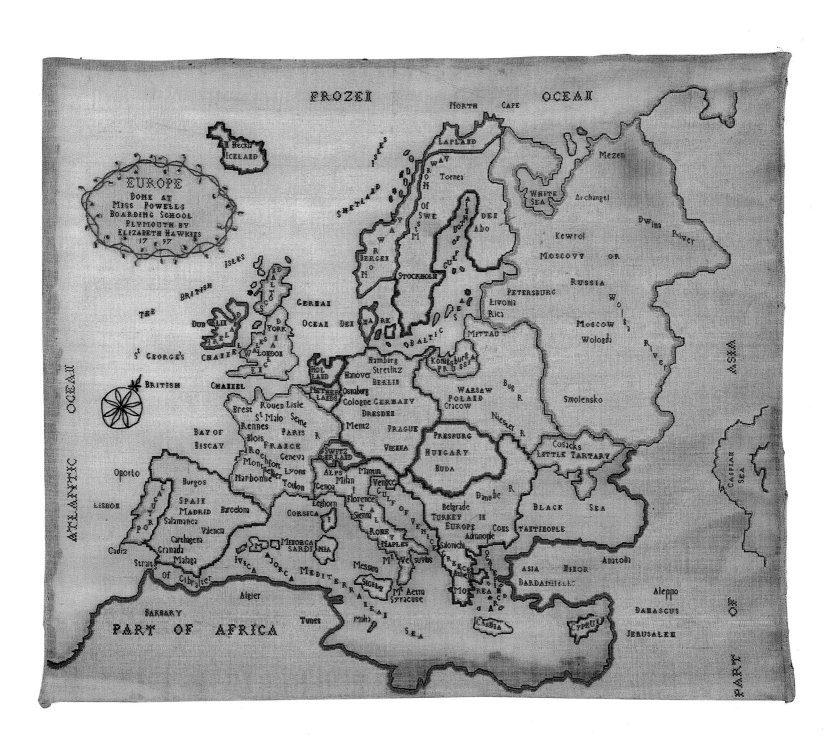

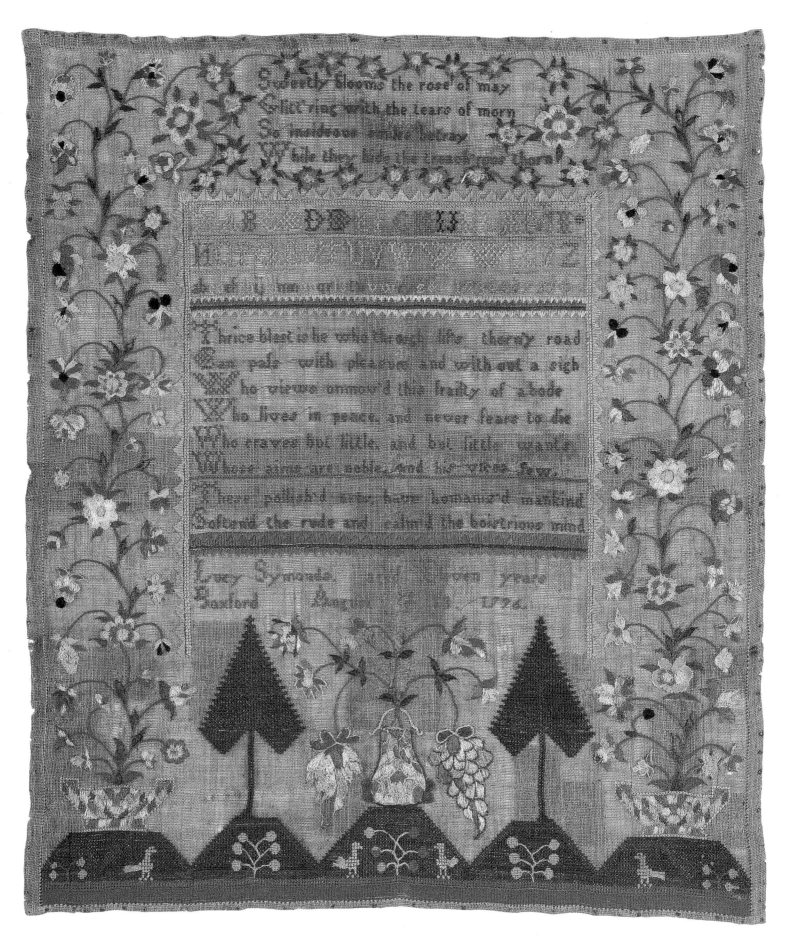

Sweetly blooms the rose of may
Glitt'ring with the tears of morn
So insidious smiles betray
.... hile they hide the treacherous thorn

Thrice blest is he who through life's thorny road
Can pass with pleasure and without a sigh
Who views unmov'd this frailty of abode
Who lives in peace, and never fears to die
Who craves but little, and but little wants
Whose aims are noble, and his vices few.

These polish'd arts have humaniz'd mankind
Softened the rude and calm'd the boisterous mind

Lucy Symonds years
Saxford 1794.

PLATE 62
American;
dated 1794
T.30-1923

88

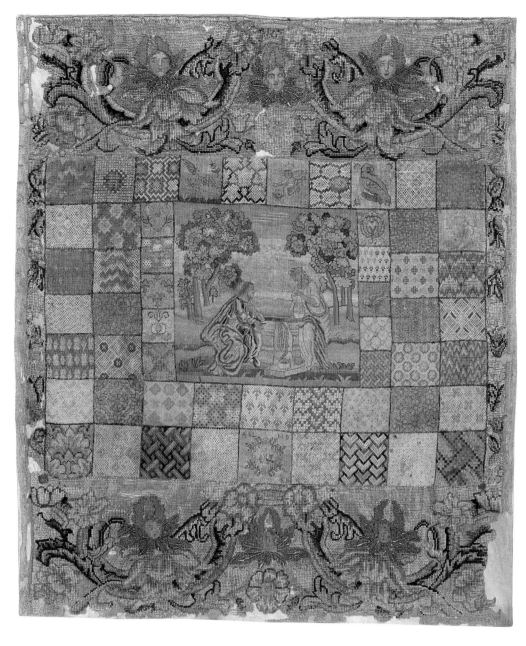

PLATE 63
Danish or Swedish;
dated 1751
T.59-1914

Detail

PLATE 64
Danish; dated 1758
T.27-1940

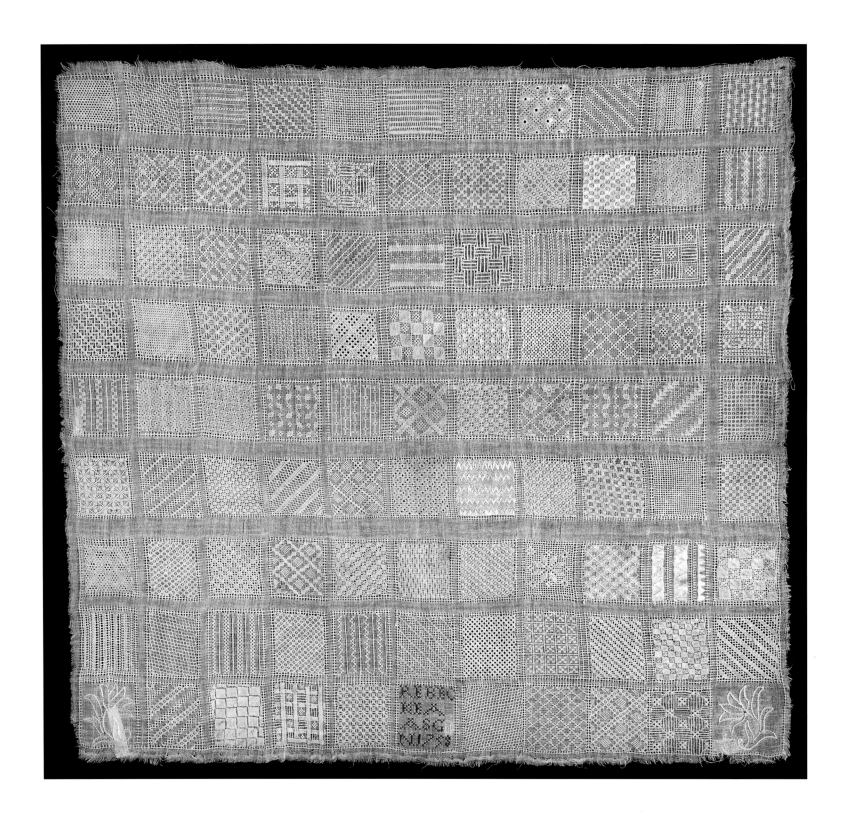

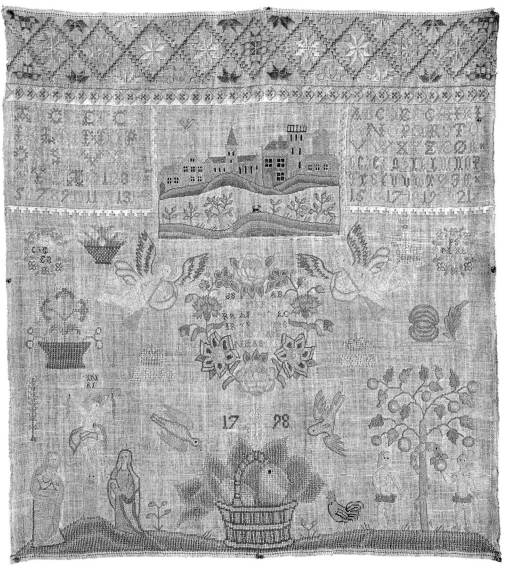

PLATE 65
Danish; dated 1798
T.184-1921

Details

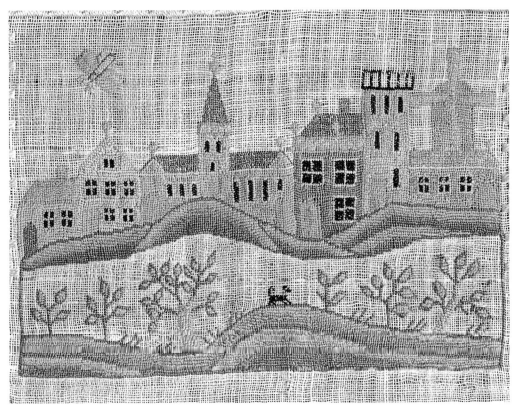

91

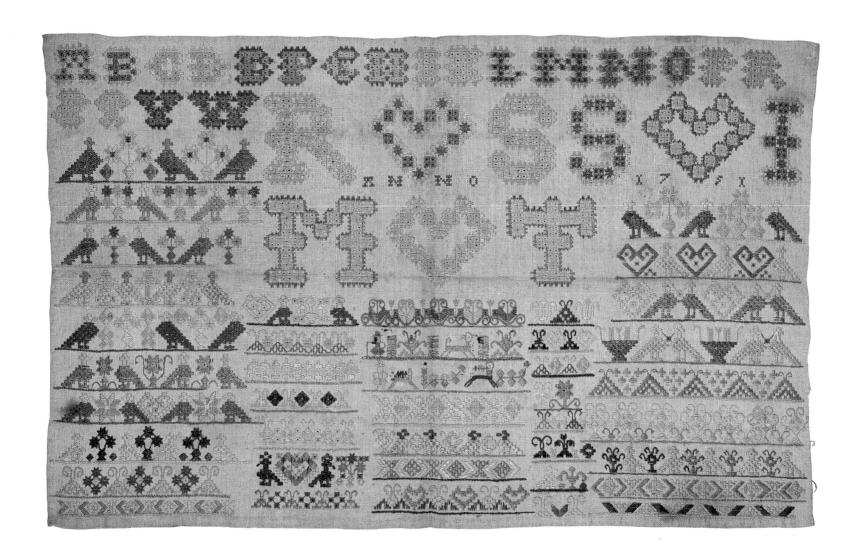

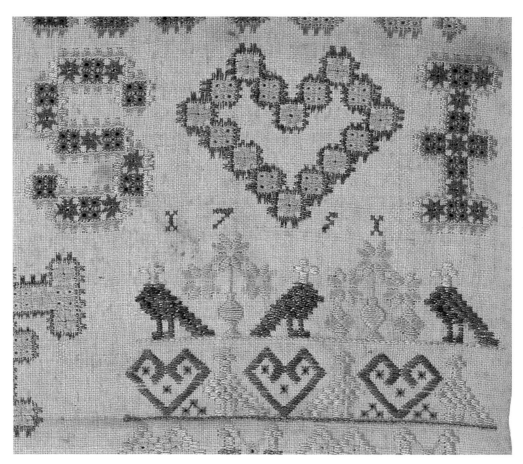

PLATE 66
Dutch; dated 1751
T.285-1960

Detail

92

PLATE 67
Dutch; dated 1763
T.186-1921

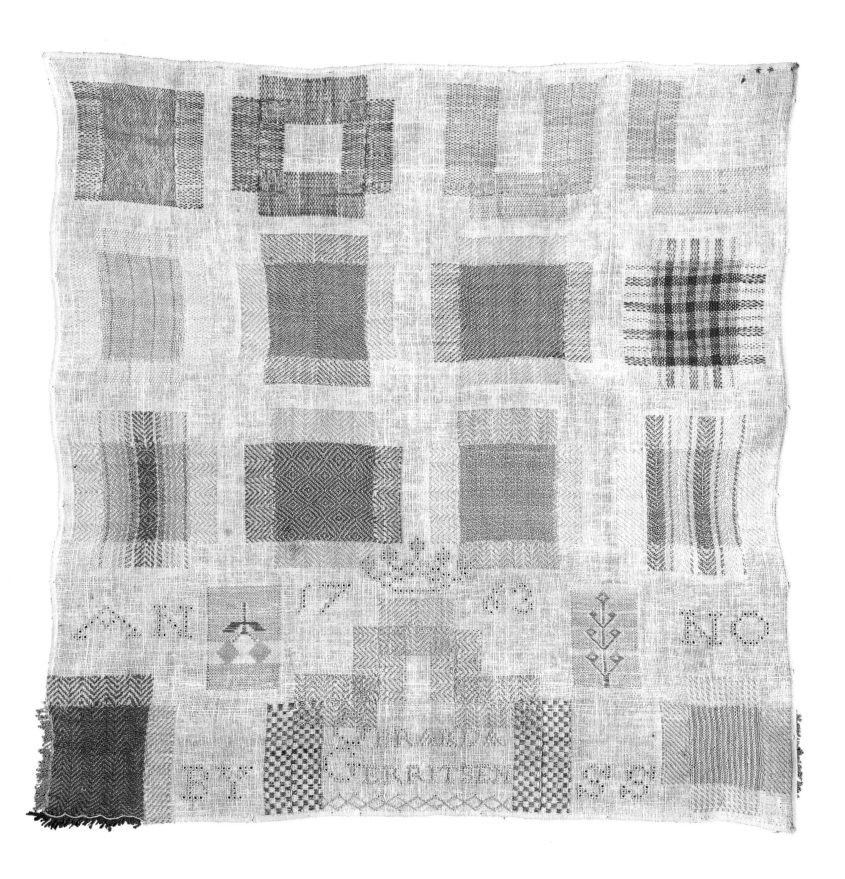

PLATE 68
Dutch; dated 1782
T.283-1960

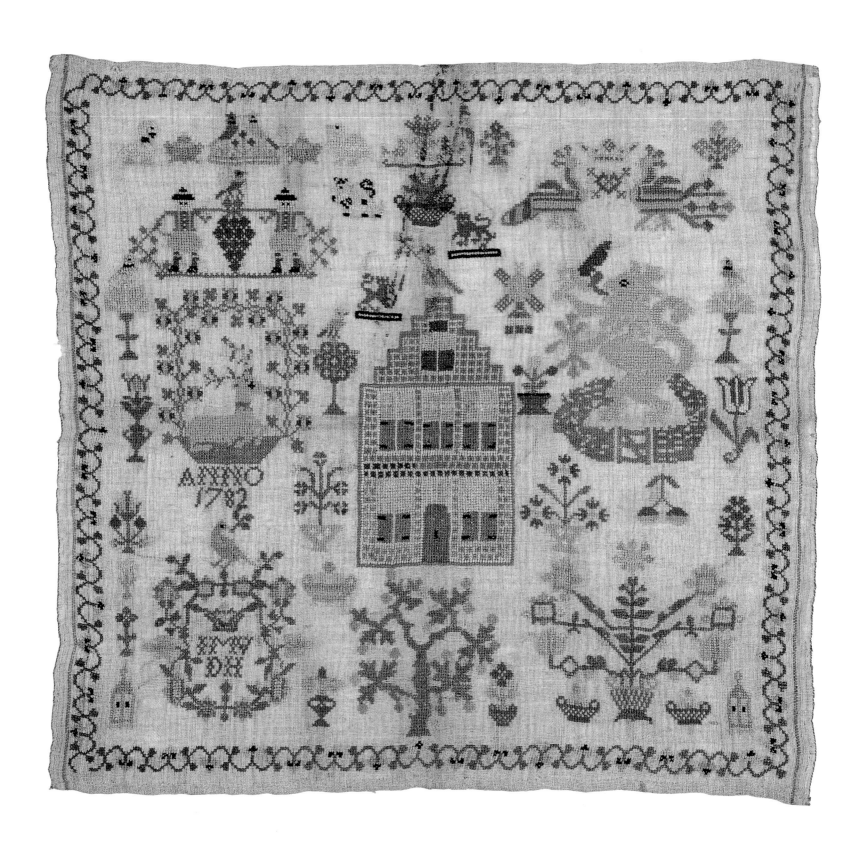

Plate 69
Dutch; dated 1803
T.95-1934

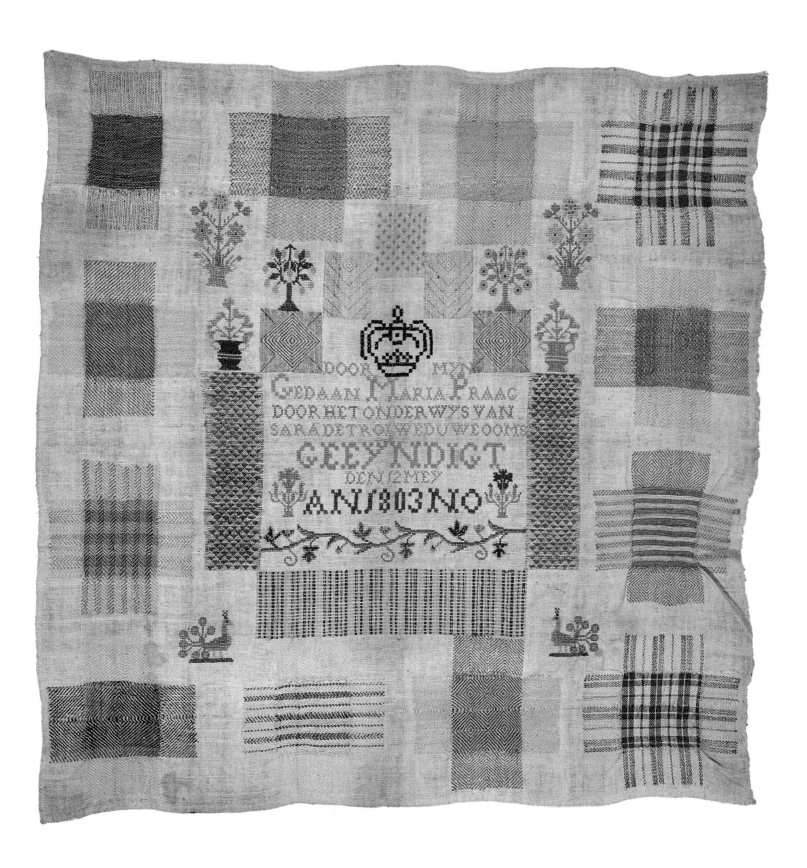

PLATE 70
Spanish; dated 1756
T.129-1909

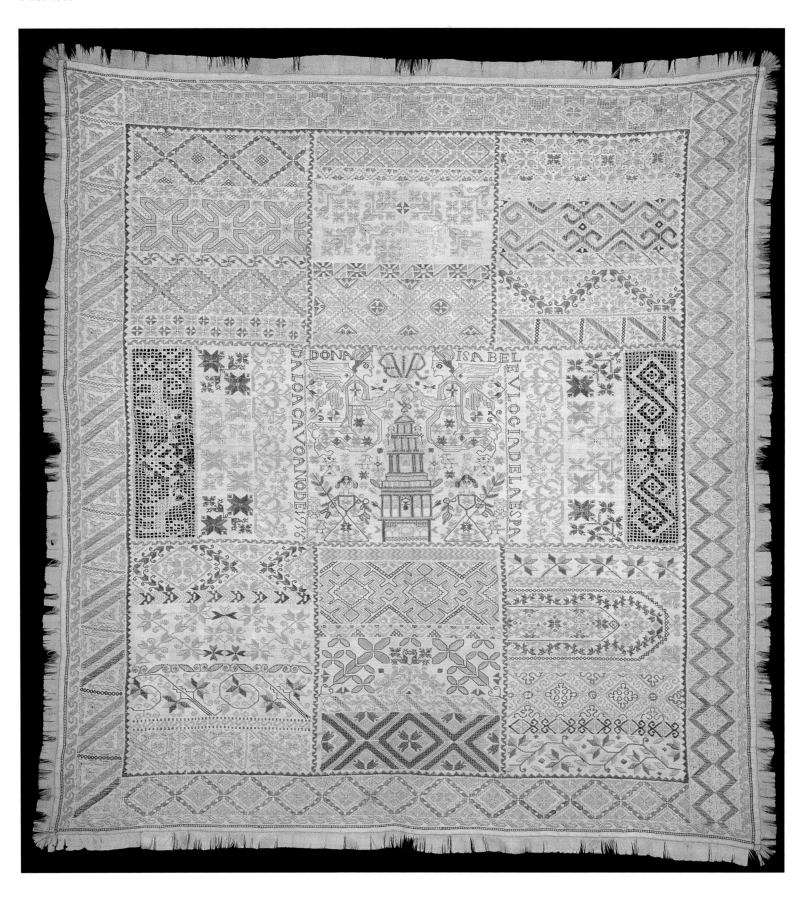

PLATE 71
Spanish;
18th century
T.84-1931

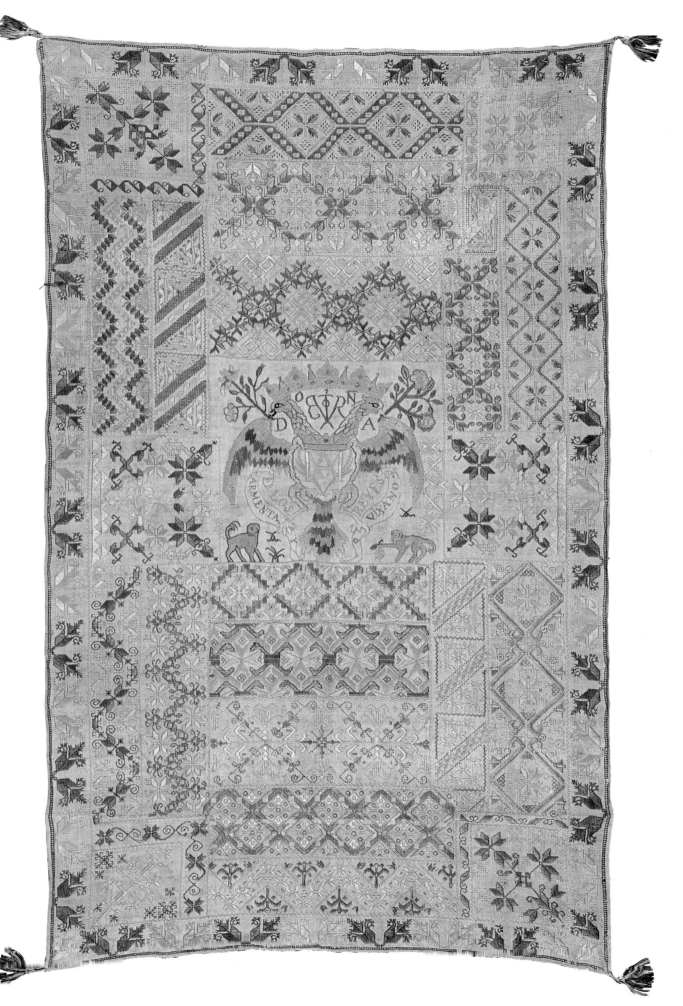

PLATE 72
Spanish; 18th or
early 19th century
(dated but unclear)
609-1884

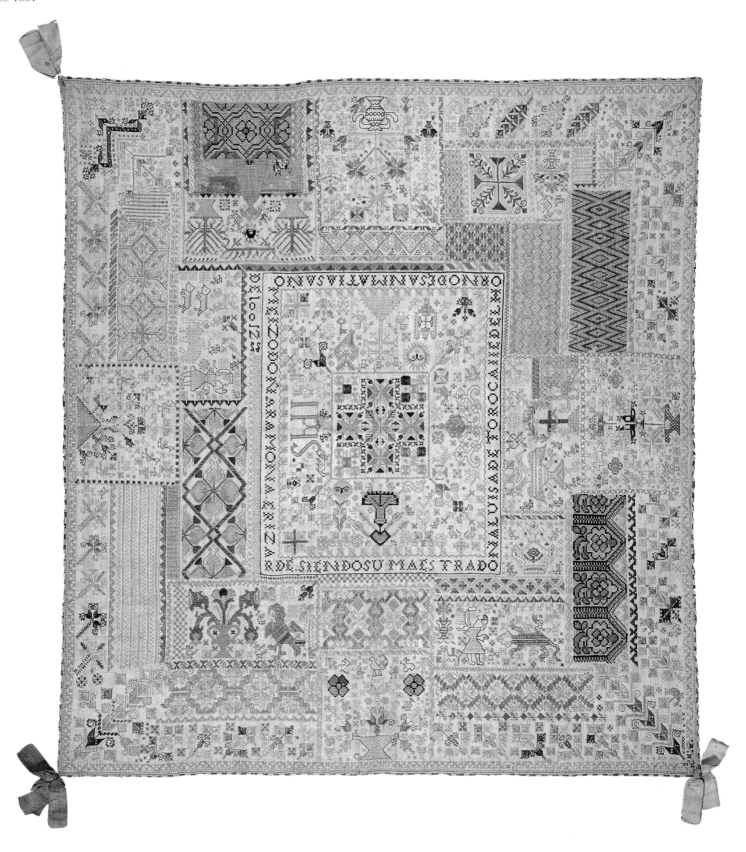

PLATE 72
Details

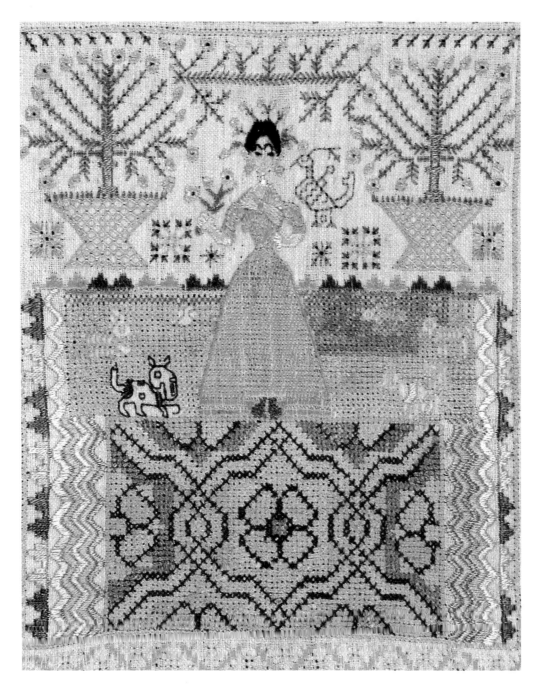

PLATE 73
English; dated 1800
T.96-1939

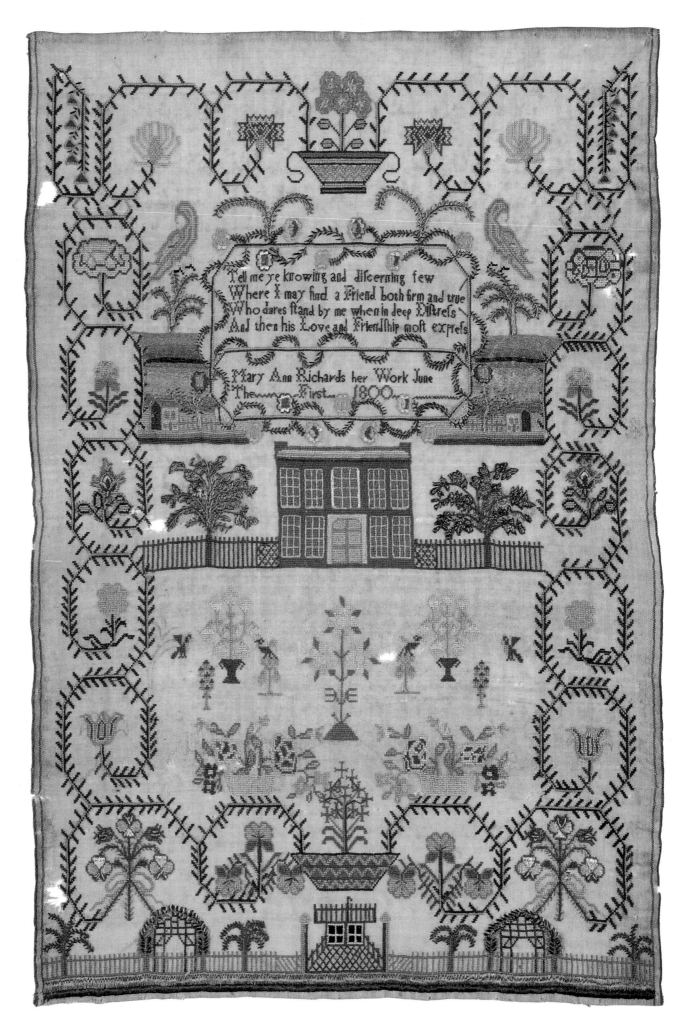

PLATE 74
English; *circa* 1800
T.97-1939

Detail

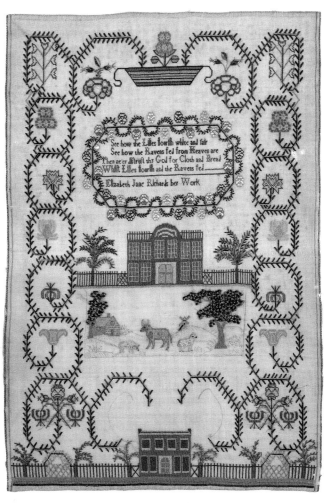

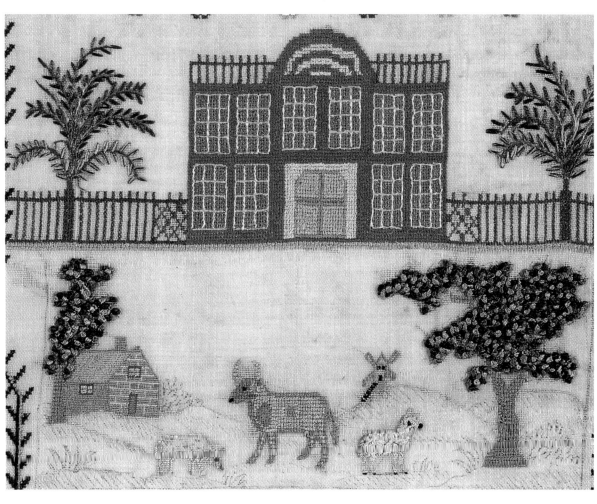

PLATE 75
English; dated 1803
942-1897

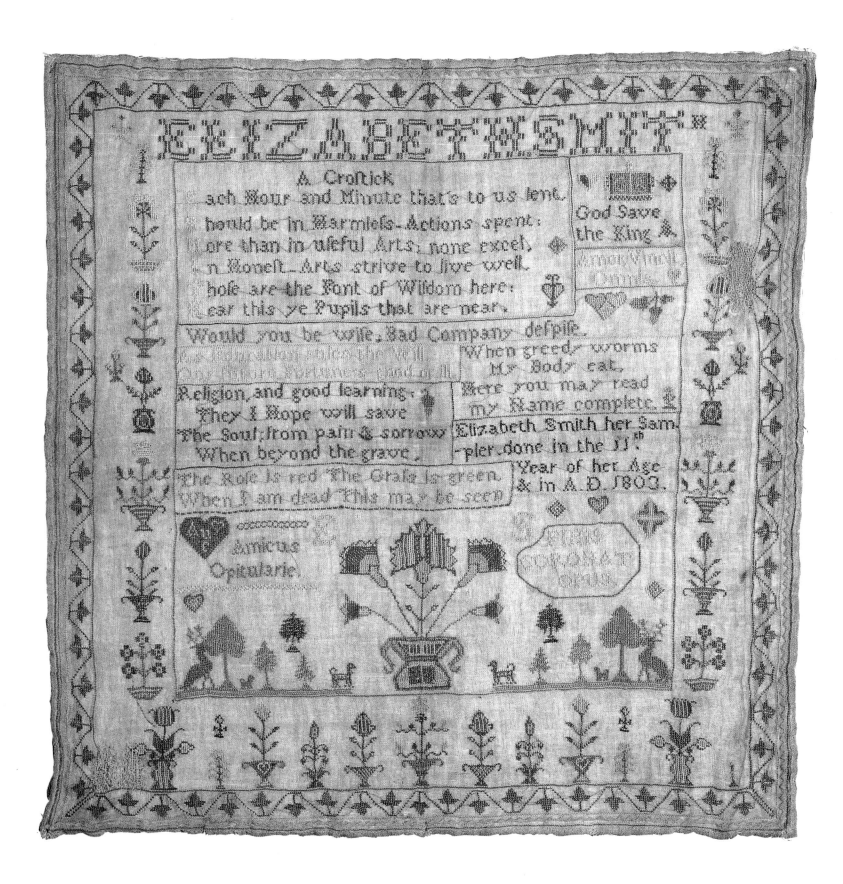

PLATE 76
English; dated 1806
590-1894

Detail

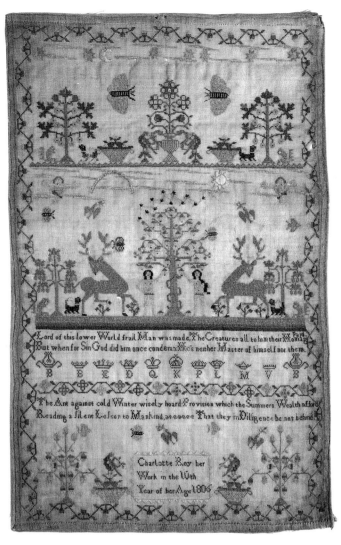

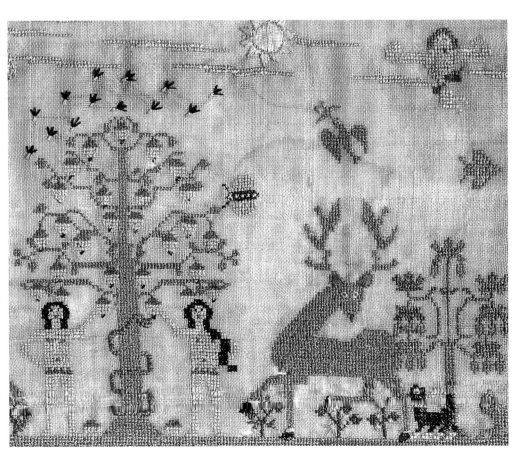

103

PLATE 77
English; early
19th century
1373-1900

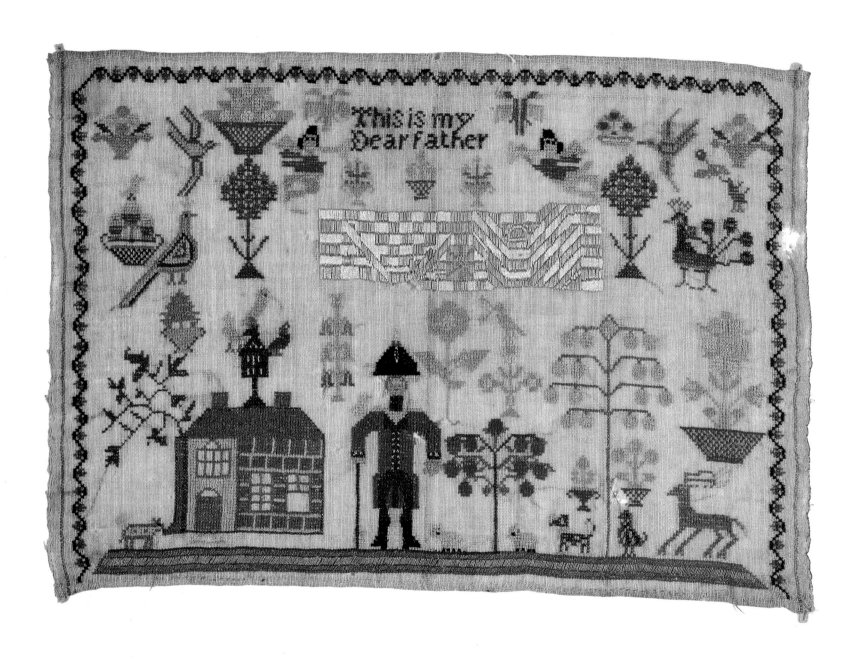

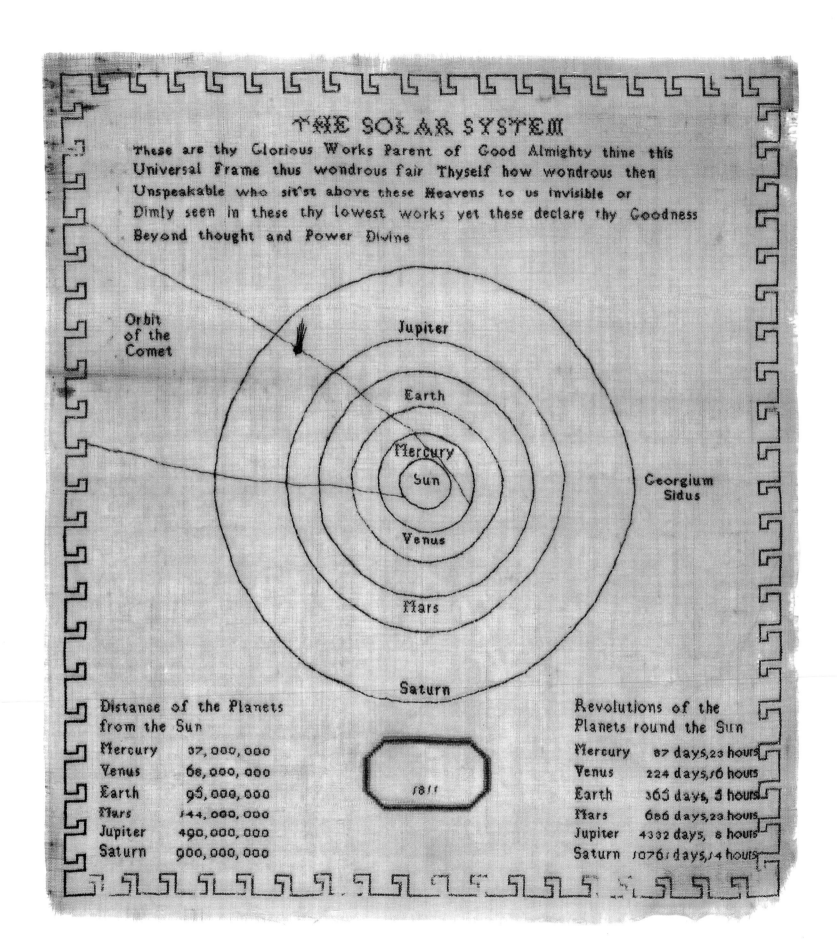

THE SOLAR SYSTEM

These are thy Glorious Works Parent of Good Almighty thine this
Universal Frame thus wondrous fair Thyself how wondrous then
Unspeakable who sit'st above these Heavens to us invisible or
Dimly seen in these thy lowest works yet these declare thy Goodness
Beyond thought and Power Divine

Orbit of the Comet

Jupiter

Earth

Mercury

Sun

Georgium Sidus

Venus

Mars

Saturn

1811

Distance of the Planets from the Sun		Revolutions of the Planets round the Sun	
Mercury	37,000,000	Mercury	87 days, 23 hours
Venus	68,000,000	Venus	224 days, 16 hours
Earth	95,000,000	Earth	365 days, 5 hours
Mars	144,000,000	Mars	686 days, 23 hours
Jupiter	490,000,000	Jupiter	4332 days, 8 hours
Saturn	900,000,000	Saturn	10761 days, 14 hours

PLATE 78
English; dated 1811
T.92-1939

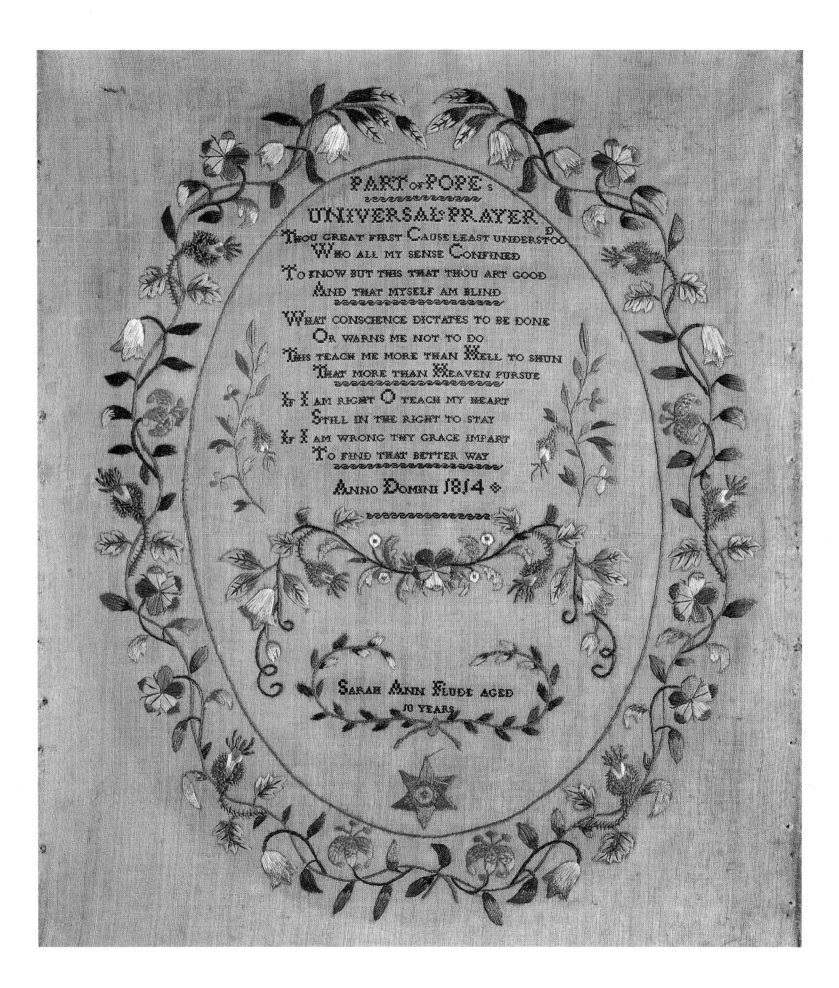

PLATE 79
English; dated 1814
T.4-1942

PLATE 80
English; dated 1827
T.133-1961

Detail

ABCDEFGHIJKLMNOPQRSTUVWXYZ

1 2 3 4 5 6 7 8 9 10 11 12 13 14 15 16 17 18 19 20

ABCDEFGHIJKLMNOPQRSTUVW&

WXYZ abcdefghijklmnopqrstuvw

XYZ& MULTIPLICATION

King Quee Duke Bisho
Prince Marquis

VIRTUE

Virtue's the chiefest beauty of the mind,
The noblest ornament of human-kind,
Virtue's our safeguard and our guiding star,
That stirs up reason when our senses err.

Sarah Grace Feb.ry 13 1827

MULTIPLICATION

1	2	3	4	5	6	7	8	9	10	11	12
2	4	6	8	10	12	14	16	18	20	22	24
3	6	9	12	15	18	21	24	27	30	33	36
4	8	12	16	20	24	28	32	36	40	44	48
5	10	15	20	25	30	35	40	45	50	55	60
6	12	18	24	30	36	42	48	54	60	66	72
7	14	21	28	35	42	49	56	63	70	77	84
8	16	24	32	40	48	56	64	72	80	88	96
9	18	27	36	45	54	63	72	81	90	99	108
10	20	30	40	50	60	70	80	90	100	110	120
11	22	33	44	55	66	77	88	99	110	121	132
12	24	36	48	60	72	84	96	108	120	132	144

As i cannot write I put this down simply and freely as I might speak to a person to whose intimacy and tenderness I can fully intrust myself and who I know will bear with all my weaknesses ——
I was born at Ashburnham in the county of Sussex in the year 1813 of poor but pious parents my fathers occupation was a labourer for the Rt Hon the Earl of A my Mother kept the Rt Hon
the Countess of A' Charity school and by their ample conduct and great Industry were enabled to render a comfortable living for their family which were eleven in number William samuel mary ——
Edmond Jesse Elizabeth Hannah Jane George Louisa Lois endeavouring to bring us up in the fear and admonition of the lord as far as lay in their power always giving us good advice and wishing us ——
to do unto others as we would they should do unto us thus our parents pointed out the way in which we were to incounter with this world wishing us at all times to put our trust in god to
walk in the paths of virtue to bear up under all the trials of this life even till time with us should end But at the early age of thirteen I left my parents to go and live with Mr and Mrs P. to ——
nurse the children which had I taken my Fathers and Mothers advice I might have remained in peace until this day but like many others not knowing when I was well of in fourteen months I left
them for which my friends greatly blamed me then I went to Fairlight housemaid to Lieut G but there cruel usage soon made me curse my Disobedience to my parents wishing I had taken ——
there advice and never left the worthy Family of P but then alas to late they treated me with cruelty to horrible to mention for trying to avoid the wicked design of my master I was thrown
down stairs but I very soon left them and came to my friends but being young and foolish I never told my friends what had happened to me they thinking I had had a good place and good
usage because I never told them to the contrary they blamed my temper Then I went to live with Col P Catsfield kitchenmaid where I was well of but there my memory failed me and my ——
reason was taken from me but the worthy Lady my Mistress took great care of me and placed me in the care of my parents and sent for Dr W who soon brought me to know that I was
wrong for coming to me one day and finding me persisting against my Mother for I had forsaken her advice to follow the works of darkness For I acknowledge being guilty of that great sin
of self destruction which I certainly should have done had it not been for the words of that worthy Gentleman Dr W he came to me in the year 1829 he said unto me Elizabeth I understand ——
you are guilty of saying you shall destroy yourself but never do that for Remember Elizabeth if you do when you come before that great God who is so good to you he will say unto you ——
Thou hast taken that life that I gave to you Depart from me ye cursed into everlasting fire prepared for the Devil and his Angels For the impression it has made on my mind no tongue can
tell Depart from me ye cursed but let me never hear those words pronounced by the O Lord for surely I never felt such impressions of awe striking cold upon my breast as I felt when Dr ——
W said so to me But oh with what horror would those words pierce my heart to hear them pronounced by an offended God But my views of things have been for some time very different
from what they were when I first came home I have seen and felt the vanity of childhood and youth And above all I have felt the stings of a guilty Conscience for the great Disobedience
to my parents in not taking their advice wherewith the Lord has seen fit to visit me with this affliction but my affliction is a light affliction to what I have deserved but the Lord has ——
been very merciful unto me for he has not cut me of in my sins but he has given me this space for repentance For blessed be God my frequent schemes for destroying myself were all ——
most all defeated But oh the dreadful powerful force of temptation for being much better I went to stay with Mrs Welham she being gone out one day and left me alone soon after
she was gone I thought within myself surely I am one of the most miserable objects that ever the Lord let live surely never no one had such thoughts as me against the Lord and I arose
from my seat to go into the bedroom and as I was going I thought within myself ah me I will retire into the most remotest part of the wood and there execute my design and that ——
design was that wilful design of self destruction But the Lord was pleased to stop me in this mad career for seeing the Bible lay upon the shelf I took it down and opened it and the first
place that I found was the fourth Chapter of S Luke were it tells us how our blessed Lord was tempted of Satan I read it and it seemed to give me some relief For now and not till ——
now have I been convinced of my lost and sinful state not till now have I seen what a miserable condition I have brought myself into by my sins for now do I see myself lost and undone
for ever undone unless the Lord does take pity of me and help me out of this miserable condition but the only object I have now in view is that of approaching death I feel assured
that sooner or later I must die and oh but after death I must come to Judgment what can I do to be saved what can I do to be saved from the wrath of that God which my
sins have deserved which way can I turn oh whither must I flee to find the Lord wretch wretch that I am who shall deliver me from the body of this death that I have been ——
seeking what will become of me ah me me what will become of me when I come to die and kneel before the Lord my maker oh with what confidence can I approach the mercy
seat of God oh with what confidence can I approach it And with what words must I chuse to address the Lord my maker pardon mine iniquity pardon mine iniquity O Lord for ——
It is Great Oh how great is thy mercy oh thou most merciful Lord for thou knowest even the secret desires of me thine unworthy servant O Lord I pray the Look down with an
Eye of pity upon me and I pray the turn my wicked Heart Day and night have I Cried unto the Lord to turn my wicked Heart the Lord has heard my prayer the Lord has given
heed to my Complaint For as long as life extends extends Hopes blest dominion never ends For while the lamp holds on to burn the greatest sinner may return Life is the season
God has given to fly from hell to rise to Heaven the Day of grace flees fast away their is none its rapid course can stay The Living know that they must die But ah the dead ——
forgotten lie Their memory and their name is gone They are alike unknowing and unknown Their hatred and their love is lost Their envy's buried in the dust By the will of God are
all things done beneath the circuit of the sun Therefore O Lord take pity on me I pray Whenever my thoughts do from the stray And lead me Lord to thy blest fold That I thy
glory may behold Grant Lord that I soon may behold the not as my Judge to condemn and punish me but as my Father to pity and restore me For I know with the O Lord no—
thing is impossible thou can if thou wilt restore my bodily health And set me free from sin and misery For since my earthly Physician has said he can do no more for me in the will
I put my trust O blessed Jesus grant that I may never more offend the or provoke the to cast me of in thy displeasure Forgive my sins my folly cure Grant me the help I need
And then although I am mean and poor I shall be rich indeed Lord Jesus have mercy upon me take me O kind shepherd take me a poor wandering sinner to thy fold Thou art Lord
of all things death itself is put under thy feet O Lord save me lest I fall from thee never to rise again O God keep me from all evil thoughts The little hope I feel that I shall obtain
mercy gives a happiness to which none of the pleasures of sin can ever be compared I never knew anything like happiness till now O that I may but be saved on the day of Judge—
ment God be merciful to me a sinner But oh how can I expect mercy who went on in sin until Dr W remind me of my wickedness For with shame I own I returned to thee O ——
God because I had nowhere else to go How can such repentance as mine be sincere what will become of my soul

PLATE 82
English; 1830s
T.40-1928

Detail

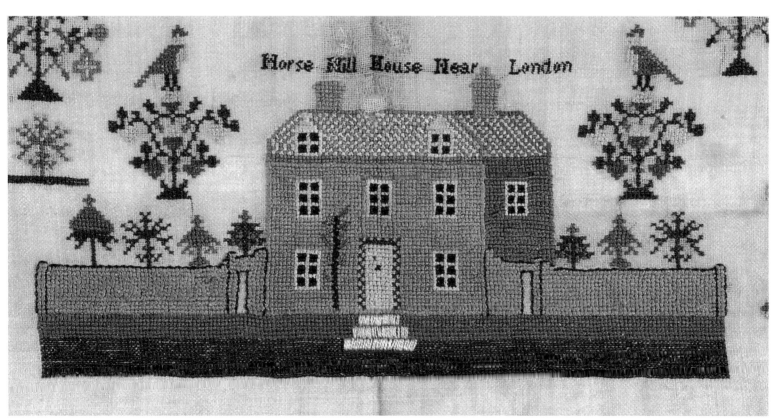

PLATE 83
English; dated 1837
T.3-1930

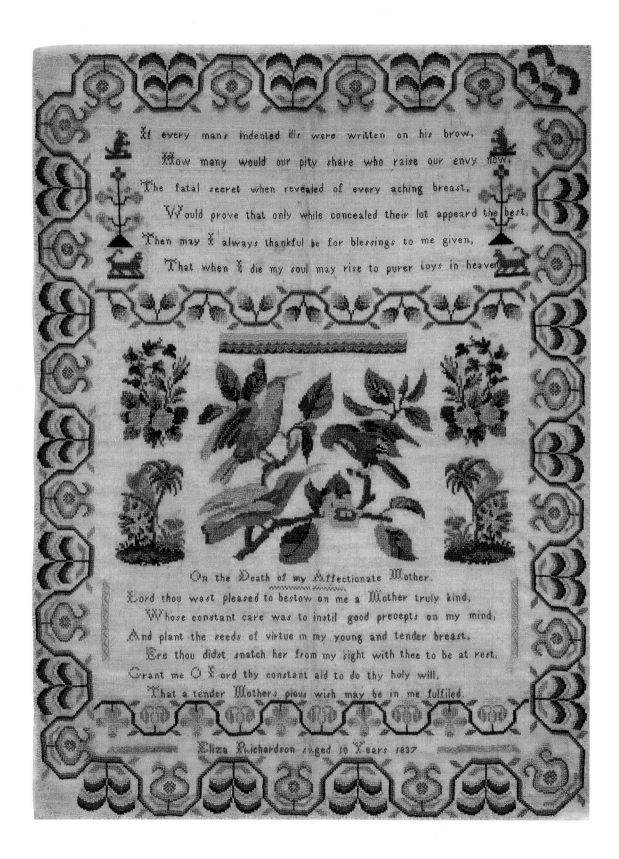

PLATE 84
English; dated 1839
T.250-1920

Detail

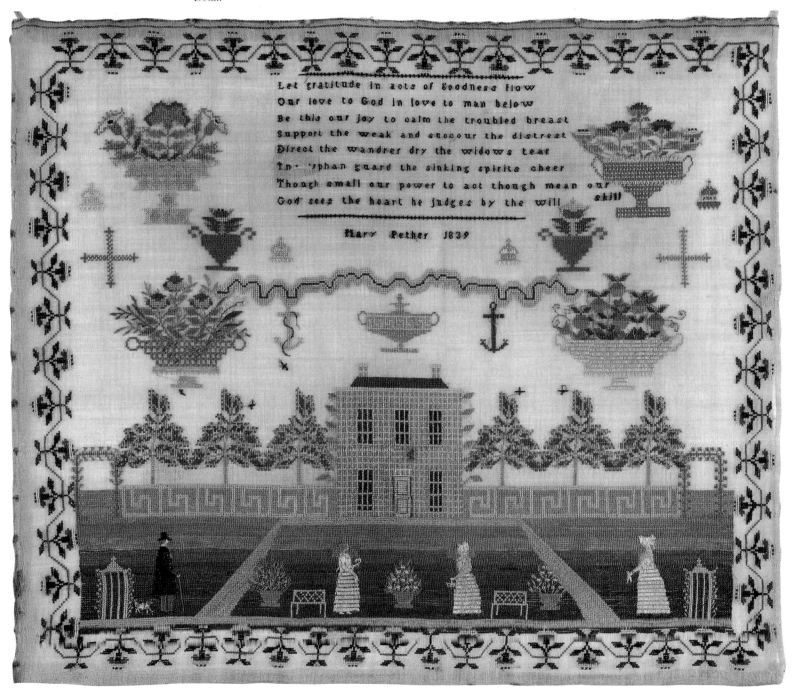

Let gratitude in acts of goodness flow
Our love to God in love to man below
Be this our joy to calm the troubled breast
Support the weak and succour the distrest
Direct the wandrer dry the widows tear
In orphan guard the sinking spirits cheer
Though small our power to act though mean our skill
God sees the heart he judges by the will

Mary Pether 1839

Detail

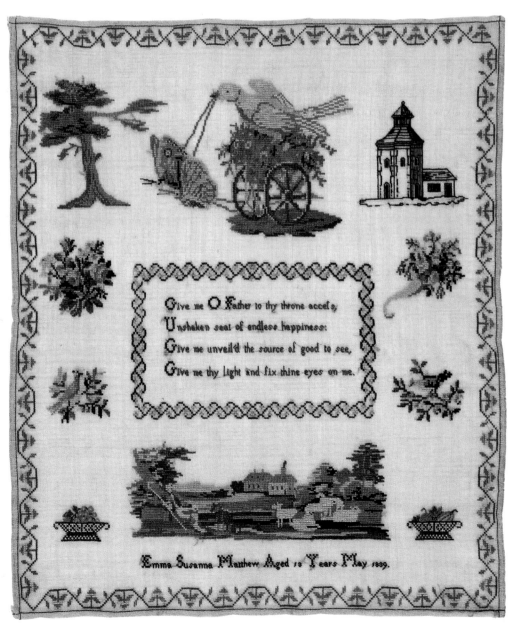

Give me O Father to thy throne access,
Unshaken seat of endless happiness:
Give me unveil'd the source of good to see,
Give me thy light and fix thine eyes on me.

Emma Susanna Matthew Aged 13 Years May 1839.

PLATE 85
English; dated 1839
T.102-1939

PLATE 86
English; *circa*
1836–40
T.94-1939

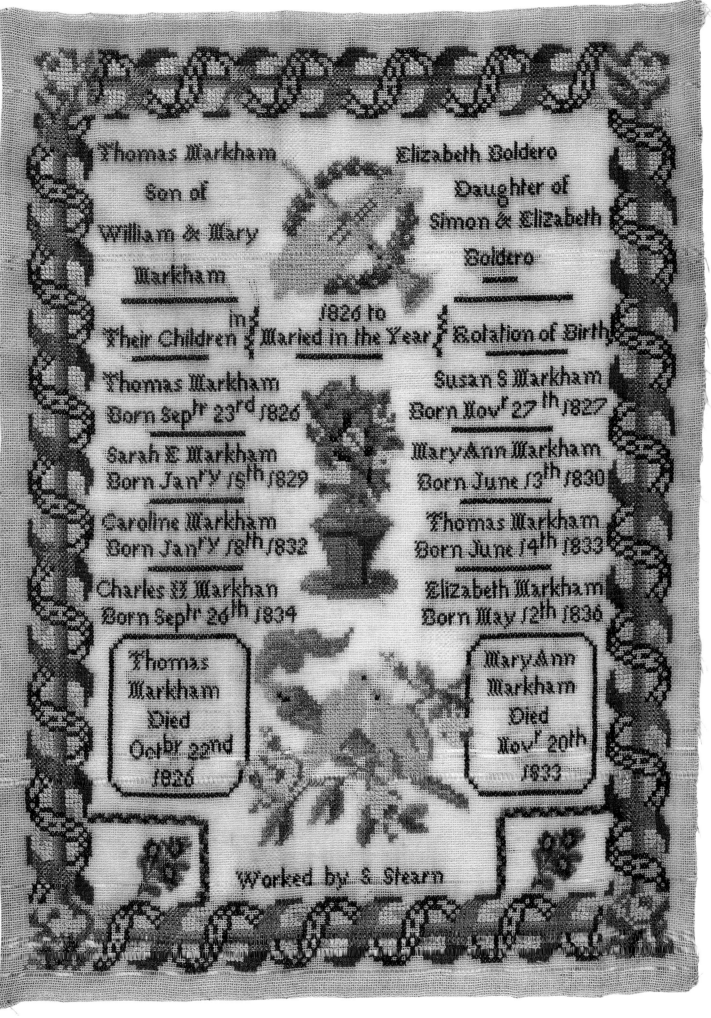

Thomas Markham Elizabeth Boldero

Son of Daughter of

William & Mary Simon & Elizabeth

Markham Boldero

in 1826 to
Their Children { Maried in the Year } Rotation of Birth

Thomas Markham Susan S Markham
Born Sept' 23rd 1826 Born Nov' 27th 1827

Sarah E Markham Mary Ann Markham
Born Jan'y 15th 1829 Born June 13th 1830

Caroline Markham Thomas Markham
Born Jan'y 18th 1832 Born June 14th 1833

Charles E Markham Elizabeth Markham
Born Sept' 26th 1834 Born May 12th 1836

Thomas Mary Ann
Markham Markham
Died Died
Octbr 22nd Nov' 20th
1826 1833

Worked by S. Stearn

PLATE 87
English;
mid-19th century
T.6-1935

Detail

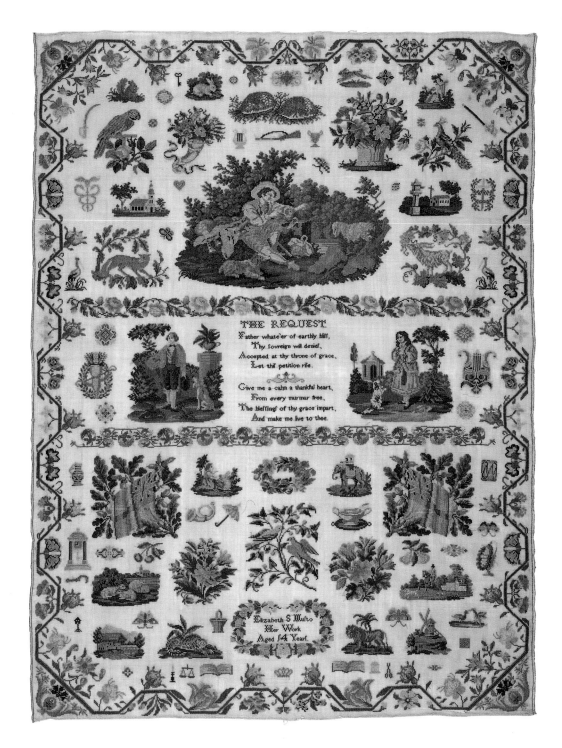

114

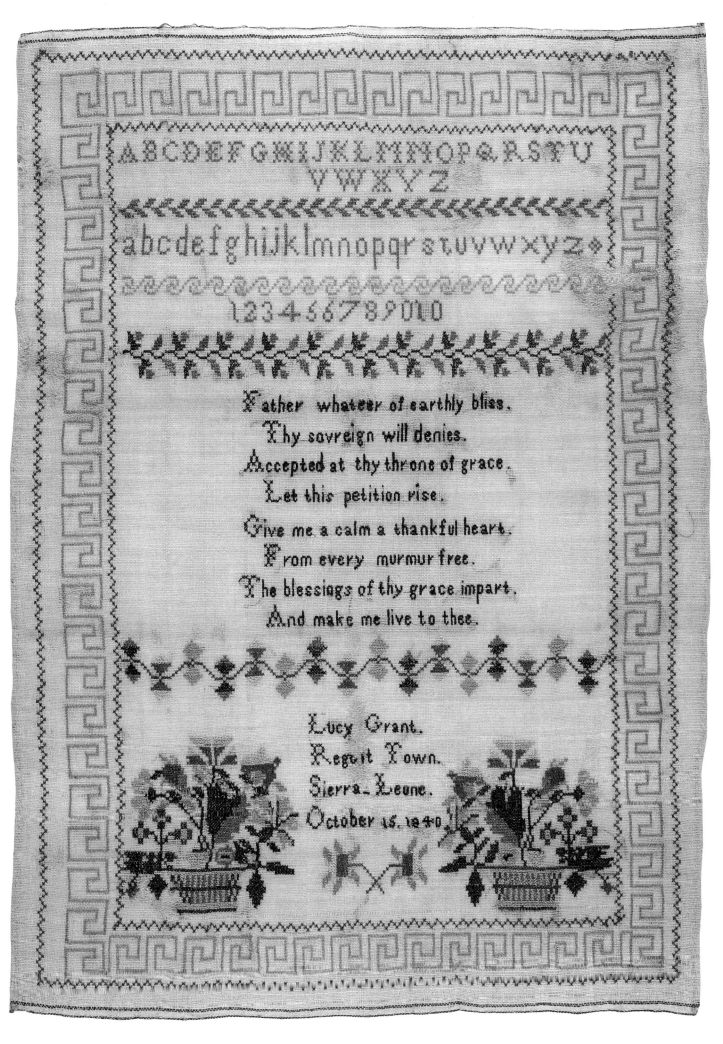

PLATE 88
British Colonial
(Sierra Leone);
dated 1840
T.54-1934

ABCDEFGWIJKLMNOPQRSTU
VWXYZ

abcdefghijklmnopqrstuvwxyz

1234567890I0

Father whateer of earthly bliss.
Thy sovreign will denies.
Accepted at thy throne of grace.
Let this petition rise.
Give me a calm a thankful heart.
From every murmur free.
The blessings of thy grace impart.
And make me live to thee.

Lucy Grant.
Reguit Town.
Sierra Leone.
October 15. 1840.

PLATE 89
English;
mid-19th century
T.240-1967

PLATE 89
Details

PLATE 90
German (Vierlande);
dated 1807
510-1899

Detail

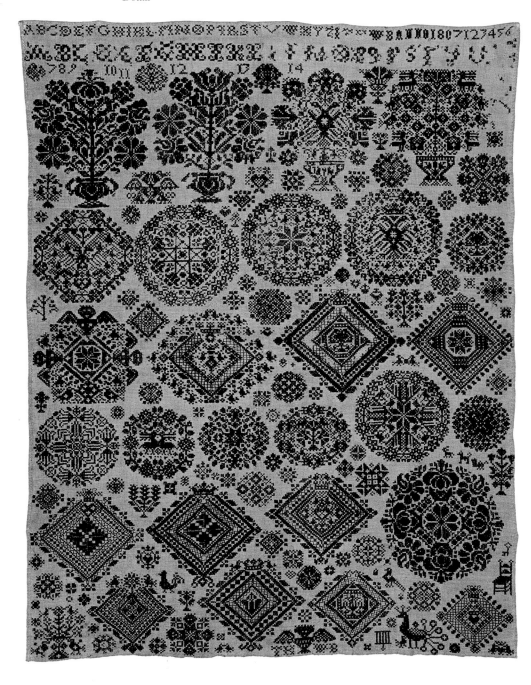

PLATE 91
French; dated 1847
T.171-1921

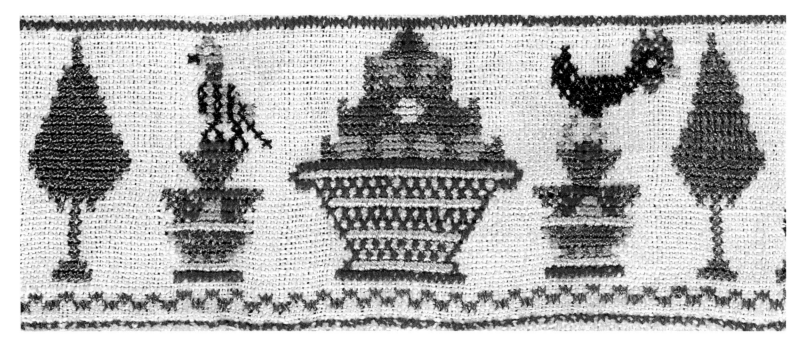

Detail

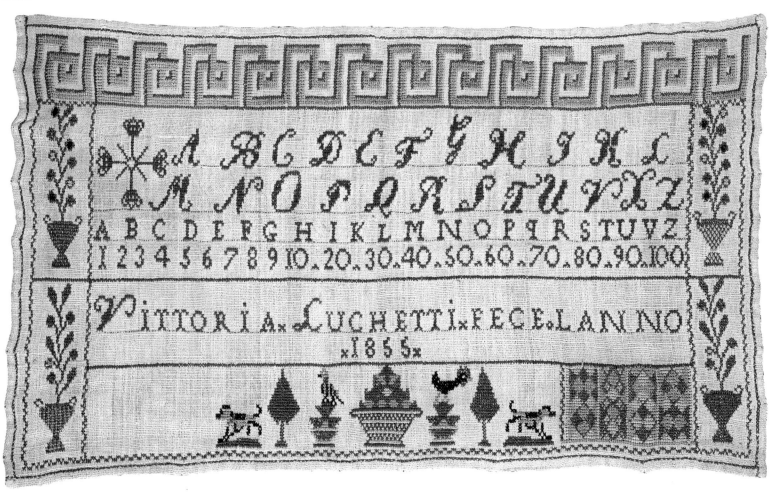

PLATE 92
Italian; dated 1855
T.24-1916

PLATE 93
Mexican; dated 1826
Circ.551-1923

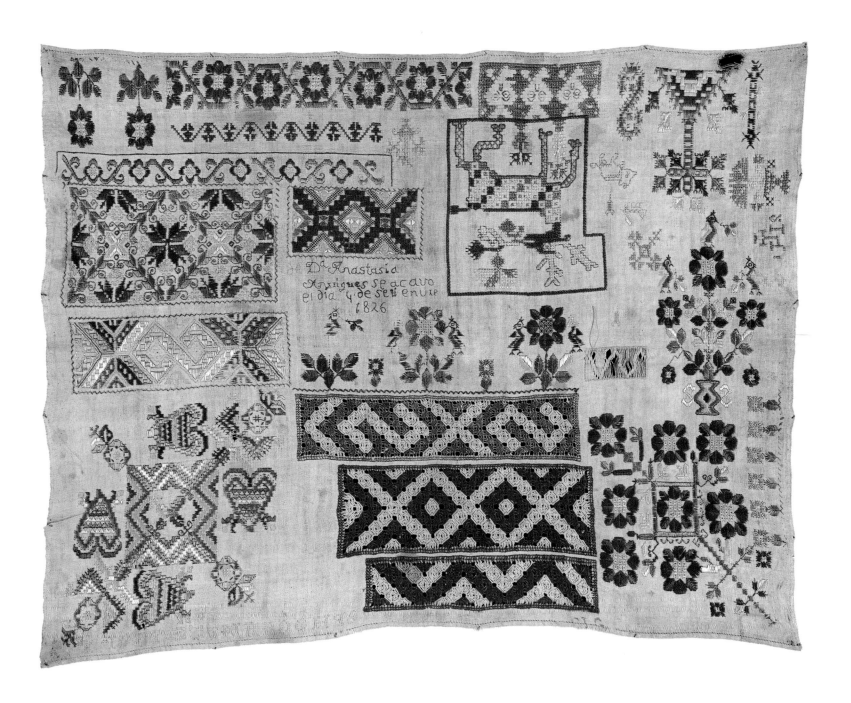

PLATE 94
Mexican; dated 1860
T.54-1931

Detail

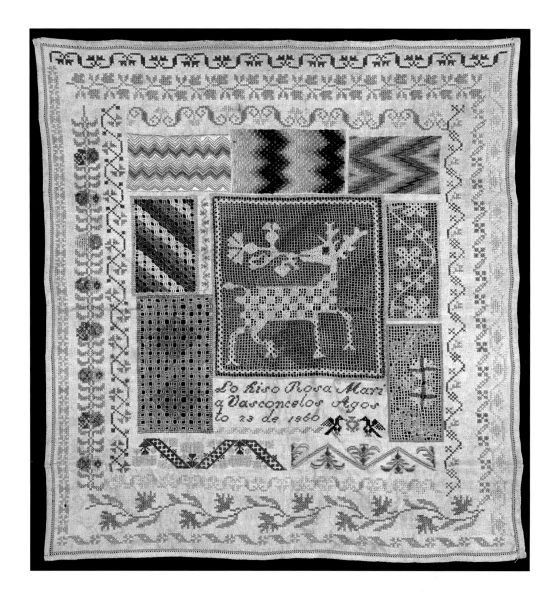

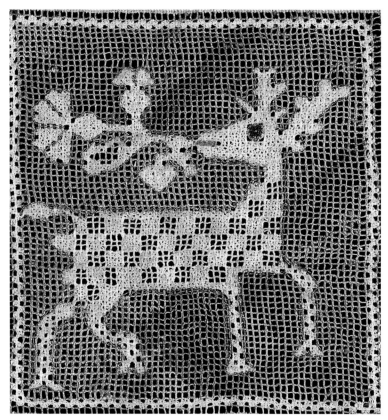

PLATE 95
Mexican;
mid-19th century
T.565-1919

PLATE 96
Swedish (Skania);
dated 1863
234-1869

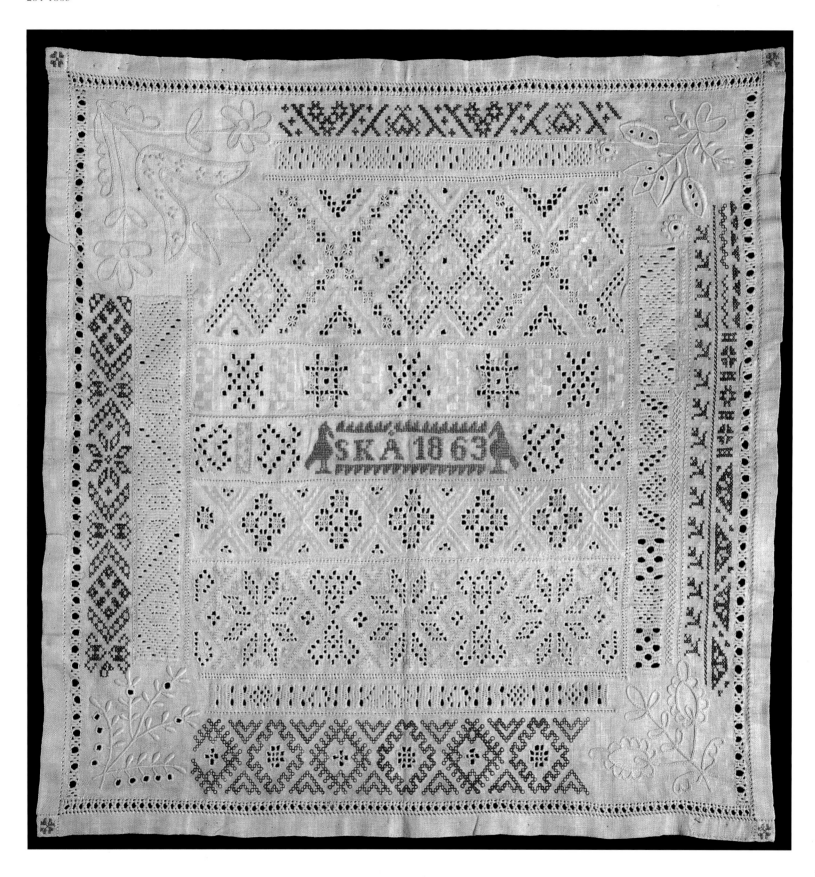

PLATE 97
German (*Gewerbeschule
für Mädchen*, Hamburg);
1884
194-1885

Detail

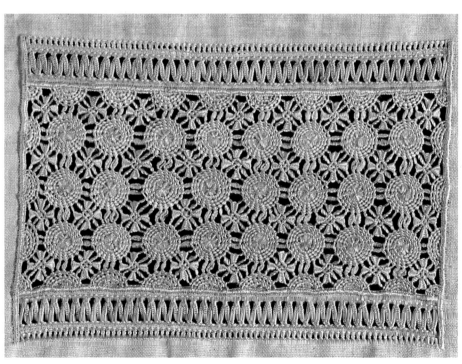

125

PLATE 98
Turkish; 19th century
T.325-1921

PLATE 99
Moroccan;
19th century
T.150-1929

127

Plate 100
Moroccan;
19th century
T.35-1933

Detail

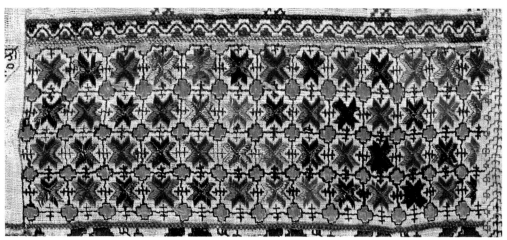

Stitches and Techniques

BY JENNIFER WEARDEN

'Without stitches there could be no art of embroidery.'
Mrs Archibald Christie[1]

GIVEN TECHNICAL ABILITY, the effects that can be created through embroidery are almost limitless. While each stitch or group of stitches have their own qualities and characteristics, it is the embroiderer's ability to select and exploit them that will transform a plain piece of fabric into a pleasing and unique work of art.

This power to perform magic with a needle comes through the embroiderer's familiarity with stitches: with their structure, with the hand movements required to make them and with their seemingly infinite variation. In 1920 Mrs Christie classified stitches by their structure and, in a more rigorously scientific way, so did Irene Emery in 1966. Both demonstrated that a great variety has developed from two or three basic stitches. That straight stitch evolved into satin, brick, long and short, tent, Gobelin, Florentine, Hungarian and others, and that running stitch evolved into double running, outline, stem, darning and more. It is this variety that often causes confusion. 'Hopeless confusion,' Marcus Huish called it, and continued: 'It is hardly too much to say that nearly every stitch has something like half a dozen names, the result of reinvention or revival by succeeding generations, while to add to the trouble some authorities have assigned ancient names to certain stitches on what appears to be wholly insufficient evidence of identity.'[2] This plethora of stitch names is not a recent phenomenon, in 1688 the following list was published to explain 'The School

Mistris Terms Of Art For All Her Ways Of Sowing':

A Samcloth, vulgarly a Sampler
Plat-stitch, or single plat-stitch which is good on one side
Plat-stitch, or double plat-stitch which is alike on both sides
Spanish stitch, true on both sides
Tent-stitch on the finger
Tent-stitch in the tent

Irish stitch	Back-stitch
Fore-stitch	Queens-stitch
Gold-stitch	Satin-stitch
Tent-stitch upon satin	
Fern-stitch	Finny-stitch
New-stitch	Chain-stitch
Bread-stitch	Fisher-stitch
Rosemary-stitch	Mow-stitch
Whip-stitch	Cross-stitch
Raised work	Needlework Pearl
Geneva work	Virgins Device
Cut Work	Open cut work
Laid work	Stitch work and through stitch
Lap work	Rock work
Frost work	Net work
Purle work	Tent work
Finger work	

all of which are several sorts and manners of works wrought by the needle with silk....[3]

This almost hypnotic list of stitches, many of them with unimaginable form, serves to illustrate the problem of a nomenclature that has varied over the centuries and across countries and continents. The clearest exposition of both name and form is to be found in Mary Thomas's *Dictionary of Stitches* (1934) and in the index she usefully groups stitches according to their function. The great variety of stitches has evolved because each stitch has a particular function. Even the slightest variation – in the length of the stitch, the axis of the stitch or the angle of the needle – subtly changes the role that particular stitch plays in an embroidery. It is the understanding of function that gives the embroiderer power to create.

The patterns in samplers had their functions too. What could be more functional than a darning sampler with its exercises in how to repair holes and

PLATE 101. Pattern darning; detail of plate 67

worn areas in woven fabrics? In the most carefully worked samplers holes were actually cut into the fabric, in others (see plate 101) there was no hole and the darning was worked entirely on the fabric. Lines of running stitch were made, first along the length of the sampler to replace or strengthen the warp and then across the width of the sampler to replace or strengthen the weft. To extend the life of a damaged fabric it was important to reproduce the woven structure as closely as possible in order to eliminate unequal tensions and to maintain any continuity of design so, in this case, the stitches have been worked regularly over two threads and under two threads to create a small-scale repeating pattern. Coloured silks have been used to show clearly how the repair should be worked, but if suitable threads and colours had been selected to match the ground fabric, the darned area would have been invisible and would have been as strong and serviceable as the original fabric. Despite the beauty of these darned patterns, which could be used to form interesting backgrounds in other embroideries, they were primarily utilitarian and were never intended to be seen.

In contrast, other patterns recorded on early samplers were first and foremost decorative and fall into two main types: those which add pattern to a basically unaltered ground, and those which create pattern by changing the structure of the ground.

Simple, delicate border patterns worked in double running stitch (see plate 102) were completely reversible, identical on

PLATE 102. Double running stitch; detail of plate 17

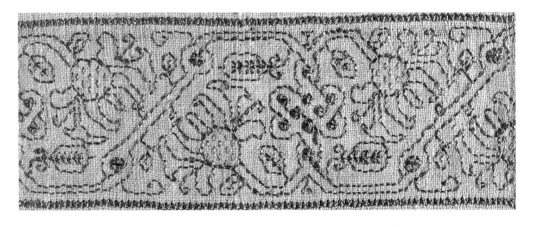

130

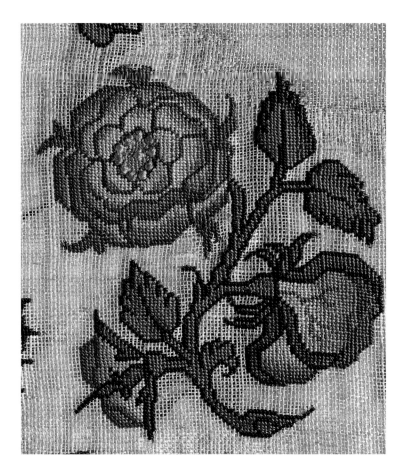

PLATE 103. Tent stitch; detail of plate 11

the coloured silks are gently moved to one side, the dark under-drawing is visible. It marked only the outline and the main internal lines – as they might have shown through the paler colours of embroidery thread, no lines were used to indicate where the leaves and petals should be shaded. This was left to the eye and the skill of the embroiderer, who sometimes chose slight gradations from pale to dark and at other times chose bolder contrasts. Given that great care was taken to create a naturalistic form in this time-consuming way, it is surprising that faint lines of silk thread are visible through the unembroidered ground fabric as they have been carried across the back from one area to another. The untidiness was of no consequence as the back of these spot motifs would never have been seen: for the most part such motifs of animals, flowers, birds

PLATE 104. The use of texture; detail of plate 11

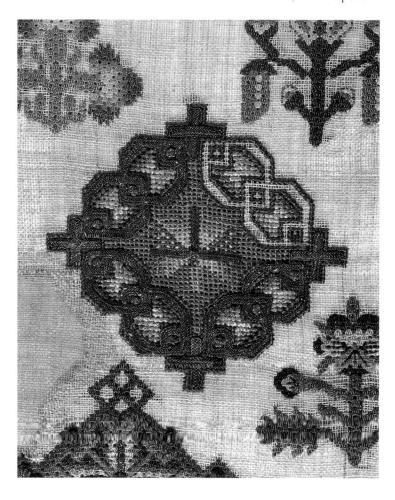

the back and front, and were perfectly suited to decorate any edges where the wrong side might easily be glimpsed – on collars, cuffs and hems, or on the sides of covers and bed linen. Although double running stitch had largely disappeared from West European embroidery by the mid-eighteenth century, it continued to be used elsewhere, especially in Turkey and in North Africa. Some embroideries may have the appearance of double running stitch, but are not reversible (see plate 5). In these examples the same delicate surface patterns have been embroidered with back stitch, which is a much faster way of working but one which sacrifices reversibility. One stitch may be used alone to create wonderful patterns: it might be the deceptive simplicity of a line of double running stitch or it might be the solidity of densely packed tent stitch (see plate 103). Occasionally it is possible to see the lines of black ink that marked out the motifs to be embroidered – in this example, if

and insects would have been worked on a fine linen and then cut around and applied as ornamentation to a stouter furnishing fabric, to be used as decorative panels or hangings. It was necessary therefore that they should possess a certain degree of stability and a counted thread stitch, such as tent stitch, would allow the embroiderer scope for realistic modelling and at the same time would build a solid and robust motif suitable for applied work.

No underdrawing can be seen beneath the threads of the geometric motifs on the same sampler (see plate 104), as their straight lines could be worked by regular counting. These intricate motifs could be repeated across and above and below to form the dense patterns used to decorate small accessories such as purses. There were two desirable requirements for these fashionable articles: they should be hard-wearing and they ought to look as sumptuous as possible. Cross stitch, with equal amounts of thread on the back and the front, served to reinforce the strength of the ground fabric as did the overcasting in the centre, which created a new texture by pulling threads together to form a fine mesh. More texture was added by the use of two colours of metal thread worked in plaited braid stitch. Metal thread gave a degree of

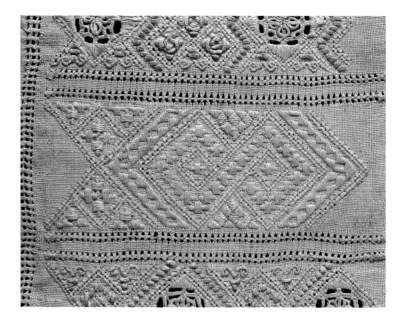

PLATE 106. Satin stitch and pulled thread work; detail of plate 37

rigidity to the embroidery as well as glitter and sparkle, but it was very expensive and so was used as surface decoration to avoid unnecessary wastage on the back.

Texture in embroidery was once of great importance (see plate 105). Texture may be subtle, like the contrast between the slightly rough, uneven surface of the rococo stitch in the strawberries and the shiny and smooth red satin stitch in the acorns above them. It may be simple, like the slight padding beneath the detached buttonhole stitch that covers the base of the acorns and swirls around to form the centre of the red roses. It may even be outrageous and appear as loose, three-dimensional rose petals in detached buttonhole stitch, anchored only at their base and standing proud of the ground. Colour is not always necessary but texture and contrast are.

It would, for example, be incorrect to think of a whitework border (see plate 106) as simple and unassuming. If there is no splash of colour to attract (or distract) the eye, great care must be taken to create a visually appealing pattern by means of contrast. Here the contrast is between the smooth, solid blocks of satin stitch and the diagonal lines of pulled thread work. Above and below the central band, greater contrast has been developed by bringing the needle through, making buttonholed bars and securing them as loops on the ground fabric, some-

PLATE 105. The use of texture; detail of plate 34

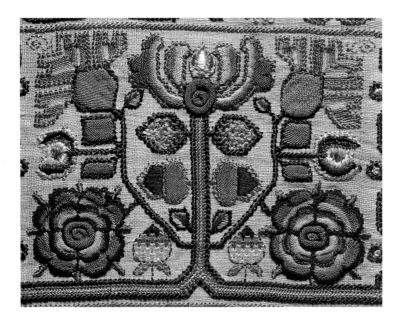

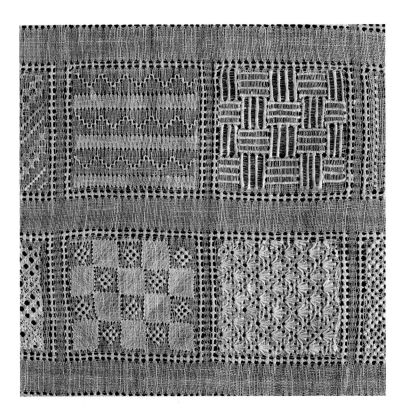

PLATE 107. Pulled thread work; detail of plate 64

Sometimes the blocks of pattern embroidered on samplers may seem too regular to be used as edgings (see plate 107), but worked on a scalloped or shaped piece of fine cotton each of these designs would have succeeded in mimicking the fine bobbin laces that were fashionable in the eighteenth century. Tiny repeating patterns have been formed by manipulating the ground fabric, by pulling threads together and securing them in new alignments, and by darning-in supplementary threads to create thicker spots on the almost transparent cotton. Less fine but more dramatic effects were created by withdrawing threads from the ground, removing them from either the warp or the weft, or from both. Those threads that remained were stitched together in varying combinations to form decorative patterns

PLATE 108. Drawn thread work; detail of plate 20

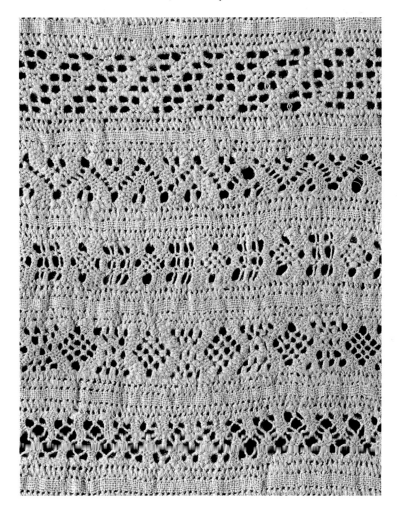

times grouping them into rosettes. It is interesting to note that the border patterns on early samplers were only ever worked as straight sections, and never demonstrate how the embroiderer ought to take a corner. Such patterns were designed to be used as edgings and not as frames, and most were to be applied to personal linen such as shirts, chemises, collars, cuffs and caps. In a play written in 1581, a rich man's wife is described using her samplers to enrich her own garments:

Now, when she had dined, then she might go seke out her examplers, and to peruse which worke would doe beste in a ruffe, whiche in a gorget, which in a sleeve, which in a quaife, which in a caule, which in a handcarcheef; what lace would doe beste to edge it, what seame, what stitch, what cutte, what garde, and to sitte her doune and take it forth by little and little, and thus with her needle to passe the after noone with devising of thinges for her owne wearyinge.[1]

(see plate 108) suitable for use as insertions or as edgings.

Breath-taking audacity must have been required to take the next step, to move from pulled thread and drawn thread work to cutwork. To remove entire blocks of the fabric, sometimes on a relatively large scale, leaving behind only a few vertical and horizontal threads on which to construct an entirely new structure. New threads, which travelled diagonally, were inserted and strengthened and then augmented with various types of buttonhole stitches to create additional loops and circles until cobweb-like patterns were formed and snowflakes hung in mid-air (see plate 109). Despite the delicacy of these designs, cutwork had to be sturdy if it was to serve as an edging, so the use of a linen ground and linen thread ensured that it would be strong, and an application of starch would impart a fashionable stiffness.

Cutwork was not always stark and dramatic. If the fillings were finer and more closely packed the effect was softer, in

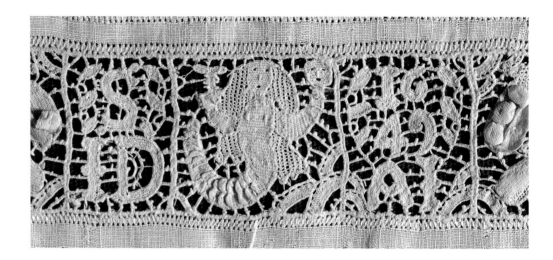

PLATE 110. Cutwork with detached buttonhole stitch; detail of plate 22

which case textured elements were often introduced to compensate for the absence of bold simplicity. Detached buttonhole stitch produced scales on the mermaid's tail and beautifully plump peas in the pods to each side of her (see plate 110). Another version of cutwork illustrates the inventive (if rather perverse) side of human nature, which first cuts a square hole in the ground fabric and then patiently fills it with minute hollie stitch until it is whole again (see plate 111), using needlework skills to transform one thing into another.

An understanding of stitch can help to unravel the creative history of a piece of embroidery. Recently, when a mid-seventeenth century sampler (see plate 28) was unframed and unpicked from its backboard, two completely different patterns were revealed. On the front there is a solid and dependable man and woman, for which a fine detached buttonhole stitch has been used to make a satisfactory, if rather stripy, fabric to represent her gown, his doublet and breeches, and the grassy mound on which they stand. When the back of the sampler is examined (see plate 112), it can be seen that these items were originally decorated with a light and charming reversible pattern worked in double running stitch. Did this later cause displeasure so that it was concealed on the front beneath a solid skin of detached buttonhole, or was the embroiderer merely demonstrating on the sampler a newly acquired skill? Two stitches and two radically different effects. The creative

PLATE 109. Cutwork; detail of plate 36

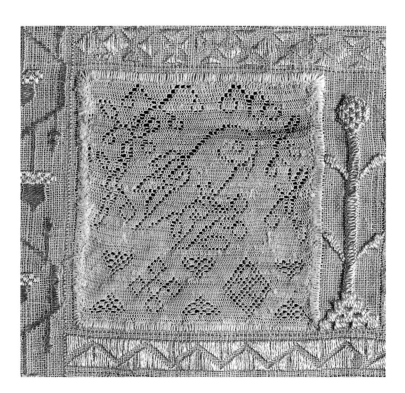

PLATE 111. Cutwork with hollie stitch; detail of plate 47

NOTES

1. Christie (1920), p.1.
2. Huish (1900), pp.143–4.
3. Holme, Randle. *The Academy of Armoury* (1688) quoted in the introduction to John L Nevinson's *Catalogue of English Domestic Embroidery of the Sixteenth and Seventeenth Centuries* (London, Victoria & Albert Museum 1938), p.xx.
4. The play is *Phylotus and Emilia* by Barnabe Riche and is quoted in Santina M Levey's *Lace a History* (London, Victoria & Albert Museum and WS Maney & Son Limited 1983), p.12. A gorget was a collar, and a quaife and a caule were types of cap.

PLATE 112. Double running stitch; detail of the back of plate 28

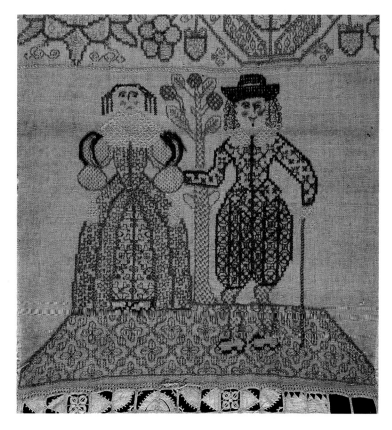

potential of stitch is almost boundless, and yet from the 18th century onwards more and more reliance has been placed on fewer and fewer stitches until the word 'sampler' has generally come to be equated with 'cross stitch'. This book may have heightened your awareness of the beauty of embroidery; it may equally easily have fostered a sense of inadequacy when faced with the technical achievements of the embroiderers of the 17th century, but it is not difficult to master the stitches used in these samplers. An explanation of the main stitches will be found in the Glossary that follows, and the most useful reference books and manuals – Christie (1920), Thomas (1934) and Emery (1966) – are listed in the Bibliography.

Glossary

BY JENNIFER WEARDEN

The diagrams and explanations in the Glossary have been based on the work of Mary Thomas and have been used by kind permission of her publishers, Hodder & Stoughton Limited.

ALGERIAN EYE STITCH: *see* eyelets.

BACK STITCH: Working from right to left the needle is brought up a little along the line to be worked (see the arrow) and is then taken back and inserted at the beginning of the line. If a regular appearance is desired, the needle should emerge an equal distance beyond the point where it began.

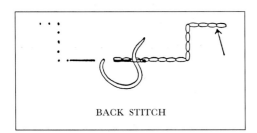

BACK STITCH

BARS: *see* buttonholed bars, needlewoven bars and overcast bars.

BRICK STITCH: The first row is worked with alternating long and short straight stitches. The stitches of subsequent rows are all equal in length and parallel; they may be arranged in groups of any number, for example: three short, three long, three short, and so on. See also long and short stitch, which is similar but in which the stitches do not have to be parallel.

BRICK STITCH

BULLION KNOT: *see* knots.

BUTTONHOLED BARS: Used in drawn thread work; buttonhole stitch is worked around groups of remaining threads (A) to form a firm bar. It may be worked as single buttonhole (B) or as double buttonhole (C). See also overcast bars and needlewoven bars.

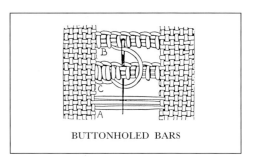

BUTTONHOLED BARS

BUTTONHOLE FILLINGS: The needle emerges through the ground fabric at (A) and makes a row of loose buttonhole stitch to (B). The return journey is from (C) to (D). The needle only enters the fabric along the outline of the motif. The buttonhole stitch may be spaced or more closely packed for different effects.

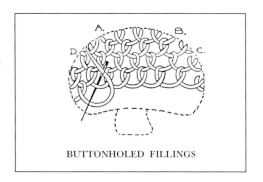

BUTTONHOLED FILLINGS

BUTTONHOLE STITCH: Worked from left to right, the needle is pulled through over the working thread to produce a straight stitch with a looped edge. See also buttonholed fillings and detached buttonhole stitch.

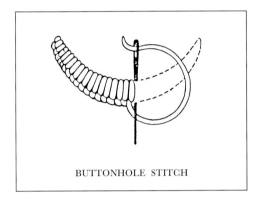

BUTTONHOLE STITCH

CHAIN STITCH: It is important that the needle is inserted into the same hole as that through which the thread emerges.

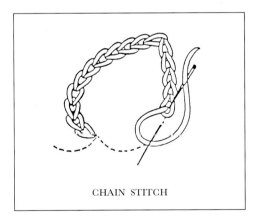

CHAIN STITCH

COUCHING: Threads are brought through from the back of the fabric, laid in position and secured by small stitches worked with either similar or contrasting thread. The securing stitches may be formed into more complex patterns.

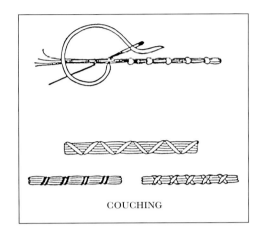

COUCHING

COUNTED THREAD STITCHES: Stitches that are worked evenly by counting the number of threads over which the needle is taken. See also freestyle embroidery.

CROSS STITCH: The needle should emerge at the arrow and is inserted to form a slanted stitch. By returning to the starting point the needle completes the stitch. There will be a line of small vertical stitches on the reverse. Cross stitch is generally worked as a counted thread stitch, but may be worked freehand. See also long-armed cross stitch, Montenegrin cross stitch, two-sided cross stitch and two-sided Italian cross stitch.

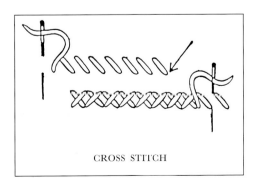

CROSS STITCH

CUTWORK: A technique used to change the structure of the ground fabric by removing blocks of warp and weft threads to create spaces. A line of stitches is run around the area to be cut and the raw edges are overcast (or whipped) with the same type of thread as the ground fabric. The space is then crossed with threads that are formed into secure bars to create patterns. Buttonhole fillings may also be used to create patterns. See also buttonholed bars, overcast bars and needlewoven bars.

DETACHED BUTTONHOLE STITCH: This begins with two long stitches taken across the top of the space and then a row of buttonhole stitch is worked over the threads (not through the fabric). If the needle goes through the ground fabric along the outlines of the motif this stitch acts as a filling (see buttonhole filling), however, if a reasonably stiff thread is used and if the detached buttonhole is secured to the ground fabric only along the original line, striking three-dimensional effects can be created.

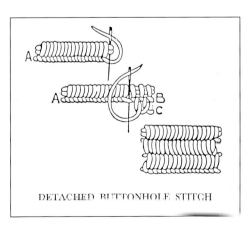

DETACHED BUTTONHOLE STITCH

DOUBLE DARNING: Close rows of double running stitches used as a filling. This creates an identical pattern on both sides of the fabric.

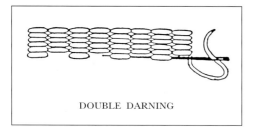

DOUBLE DARNING

DOUBLE RUNNING STITCH: Running stitch worked in two journeys over the same line, with the stitch and the space usually being of equal length – on the return journey the needle fills the spaces. Two lines of different colour have been used in the diagram below to show this more clearly. Double running stitch creates an identical pattern on both sides of the fabric.

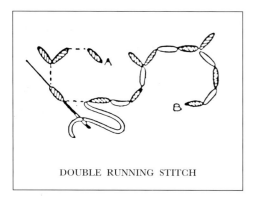

DOUBLE RUNNING STITCH

DRAWN THREAD WORK: A technique used to change the structure of the ground fabric by withdrawing some of the warp and/or weft threads and leaving others at intervals. The remaining threads are then strengthened and formed into patterns. See also buttonholed bars, needleweaving, needlewoven bars and overcast bars.

ENCROACHING SATIN STITCH: In the second and all subsequent rows the top of each stitch is taken between the base of two stitches in the preceding row. If different shades of thread are used for different rows, the colours are blended together effectively.

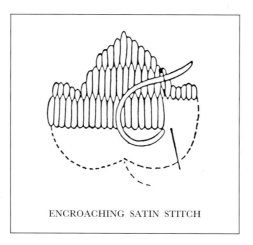

ENCROACHING SATIN STITCH

EYELETS: A small central hole from which radiate a number of straight stitches. The two most frequently used stitches are Algerian eye stitch, in which there are eight stitches, and eye stitch, in which there are 16 stitches (A), which are then framed with back stitch (B). Eyelets can be isolated or can be worked to form a solid pattern.

EYE STITCH: *see* eyelets.

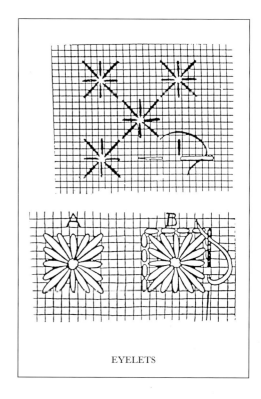

EYELETS

FLORENTINE STITCH: Straight stitches worked to form a zigzag pattern. Varying shades or colours of thread are usually used for separate rows or groups of rows.

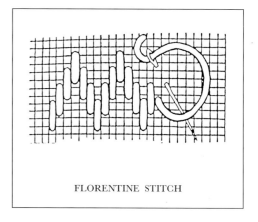

FLORENTINE STITCH

FREESTYLE STITCHES: The opposite of counted thread stitches. Stitches that may vary in length, direction, angle, and so on, according to the pattern being worked or according to the wishes of the embroiderer. Some stitches may be worked in either form. See also counted thread stitches.

FRENCH KNOT: *see* knots.

GOBELIN STITCH: This can be worked as an upright stitch, but is more usually worked as a slanting stitch going up over two threads and across one. The first row is worked from left to right (beginning at the arrow), the second row (above it) is worked from right to left with the needle pointing downwards.

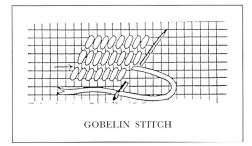

GOBELIN STITCH

HOLLIE STITCH or HOLLIE POINT: The required shape is first outlined in chain stitch and then the thread is brought through at (A), taken across to (B), taken through the fabric and brought out at (C). The thread is wound around the thumb from right to left. The needle is inserted under the loop of the first chain in the top row, passed under the thread (A–B) and between the thumb and the thread that encircles it, and is pulled through to complete the first stitch.

Once the row has been completed the thread is brought across from (D) to (C) and another row is begun.

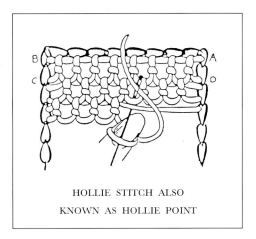

HOLLIE STITCH ALSO KNOWN AS HOLLIE POINT

HUNGARIAN STITCH: Spaced groups of three straight stitches, the middle one longer than the other two, are worked in offset rows so that all the spaces are filled. To illustrate the technique more clearly two shades of thread have been used in the diagram. As in Florentine stitch, varying shades and colours may be used to create patterns.

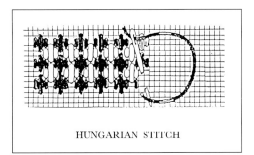

HUNGARIAN STITCH

KNOTS: The needle is brought through where the knot is required (marked on the diagrams by a small dot). Thread is twisted round the needle a number of times, and the needle is taken back and inserted close to where it was brought

out to create a small knot (French knot) and, with more twists, at a slight distance to form a longer knot (bullion knot). A number of bullion knots can be arranged together to form a larger knot.

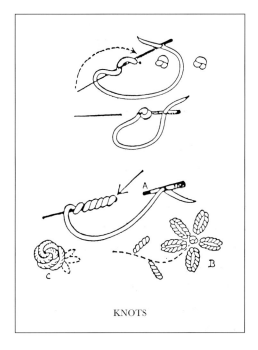

KNOTS

LONG AND SHORT STITCH: On the first row a short stitch alternates with a longer stitch (A). In subsequent rows the stitches are all of equal length and, unlike brick stitch, slant to follow the shape of the motif.

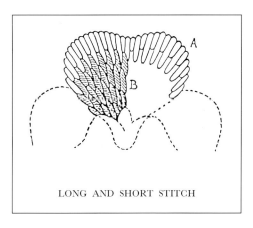

LONG AND SHORT STITCH

LONG-ARMED CROSS STITCH: The first movement of the needle is shown at (A) and the second movement at (B), where the needle is about to enter at the arrow. A row of upright stitches appears on the reverse. See also cross stitch, Montenegrin cross stitch, two-sided cross stitch and two-sided Italian cross stitch.

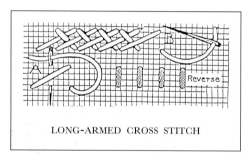

LONG-ARMED CROSS STITCH

MONTENEGRIN CROSS STITCH: This is similar to long-armed cross stitch with the addition of an upright stitch between the crosses. It is worked in two movements and forms an attractive but not identical pattern on the reverse. See also cross stitch, long-armed cross stitch, two-sided cross stitch and two-sided Italian cross stitch.

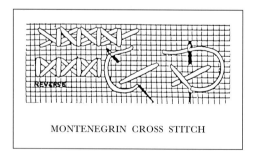

MONTENEGRIN CROSS STITCH

NEEDLE LACE STITCHES: A generic term for the stitches used to make fillings in cutwork. In embroidered samplers these are predominantly variations on buttonhole stitch.

NEEDLEWEAVING: Used in drawn thread work. Threads of the same type as the ground fabric, or occasionally of contrasting colour, are inserted with a needle to create a decorative, woven effect. See also needlewoven bars.

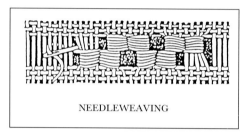

NEEDLEWEAVING

NEEDLEWOVEN BARS: Used in drawn thread work. The needle is worked over and under threads to create a woven effect when a broad and flat bar is required. See also buttonholed bars, needleweaving and overcast bars.

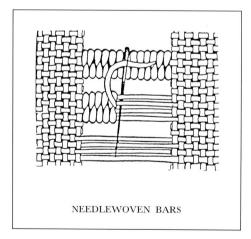

NEEDLEWOVEN BARS

OUTLINE STITCH: This is similar to stem stitch, but the thread is to the left of the needle, making the stitch twist in the reverse direction to stem stitch.

OVERCAST: To use small stitches over the raw edge of the fabric to prevent fraying.

OUTLINE STITCH

OVERCAST BARS: Used in drawn thread work. An overcast or whipping stitch is worked around remaining threads to form a firm rounded bar. See also buttonholed bars, needlewoven bars and Russian overcast filling.

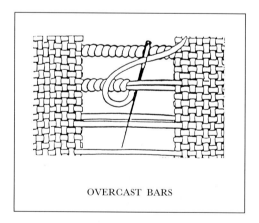

OVERCAST BARS

PATTERN DARNING: Running stitches worked in a regular sequence to form a simple repeating pattern.

PLAITED BRAID STITCH: This requires a stiff thread to be most effective. After working the stages shown as (A) to (E) once, (D) and (E) are then worked alter-

nately to form the stitch. As the needle only enters the material at (E) it is very much a surface stitch.

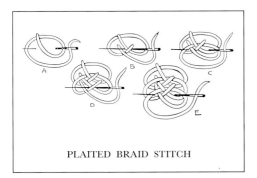

PLAITED BRAID STITCH

PULLED THREAD WORK: A technique used to change the structure of the ground fabric. Unlike cutwork and drawn thread work, no threads are removed from the ground fabric. Instead threads are pulled together tightly to create small holes.

ROCOCO STITCH: The stitch is begun by securing the threads as shown at (A). It is easier to work this in diagonal rows.

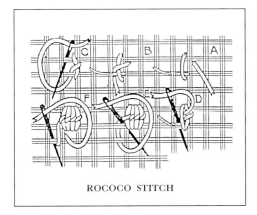

ROCOCO STITCH

ROMANIAN STITCH: This is worked along imaginary parallel lines. The needle emerges on the lower edge and is inserted opposite on the upper edge. It then emerges a short way into the centre, and to the left of the stitch just made. The thread is brought across and the needle enters the fabric on the right side of the stitch, a little lower down, and emerges on the lower line to create a long stitch tied down in the middle. A variation, sometimes called Roman stitch, has a shorter tying down stitch that is pulled more tightly.

ROMANIAN STITCH

RUNNING STITCH: The simplest of all stitches, with the needle picking up only one or two threads between each stitch.

RUNNING STITCH

RUSSIAN OVERCAST FILLING: Used in drawn thread work. An overcast or whipping stitch is worked around the remaining threads to form a firm net ground. It is easier to begin at the bottom and work up diagonally. See also overcast bars.

RUSSIAN OVERCAST FILLING

SATIN STITCH: Close and regular straight stitches, which may be worked in any direction. See also surface satin stitch.

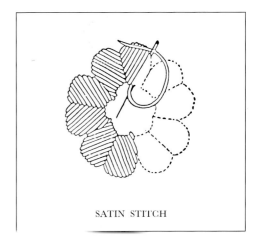

SATIN STITCH

SPLIT STITCH: Worked in the same way as stem stitch, but the needle always splits the working thread near its base, resulting in something like a fine chain stitch.

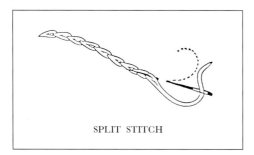

SPLIT STITCH

STEM STITCH: Worked from left to right, it consists of a long stitch forwards and a short stitch back. The thread should always be kept below or to the right of the needle. See also outline stitch.

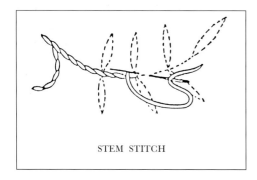

STEM STITCH

STRAIGHT STITCH: Single isolated stitches of any length and direction.

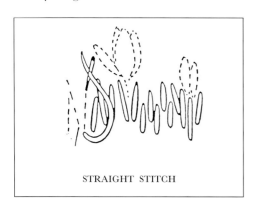

STRAIGHT STITCH

SURFACE SATIN STITCH: A method of using less thread but creating the same effect as satin stitch: instead of the needle returning under the fabric to the starting point, it takes a tiny stitch (often only one thread) and returns on the right side of the fabric.

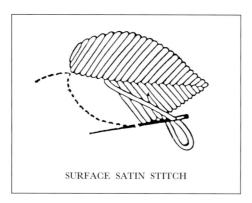

SURFACE SATIN STITCH

TENT STITCH: Can be worked on the diagonal but the method illustrated here is better for narrow lines and for small areas of colour. It can be seen that the stitch is longer on the back than it is on the front.

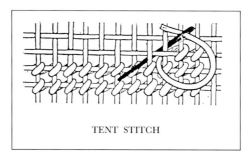

TENT STITCH

TWO-SIDED CROSS STITCH: Four movements are required to complete one row of this stitch. It is begun at the arrow on row (A) and worked from left to right, and then in the reverse direction. This stitch forms an identical pattern on both sides. See also cross stitch, long-armed cross stitch, Montenegrin cross stitch and two-sided Italian cross stitch.

TWO-SIDED CROSS STITCH

TWO-SIDE ITALIAN CROSS STITCH: This forms a cross within a square of four straight stitches, and the pattern is identical on both sides. The first diagram shows how one stitch is completed and the second diagram shows that one row is worked in two movements, first from left to right and then from right to left.

TWO-SIDE ITALIAN CROSS STITCH

See also cross stitch, long-armed cross stitch, Montenegrin cross stitch and two-sided cross stitch.

WARP: The threads that run the length of a woven fabric.

WEFT: The threads that are interlaced with the warp, and that run across the width of a woven fabric.

WHIP: *see* overcast.

A study of the Glossary will show clearly that some stitches have more than one function but, based on the use of stitch in these samplers, they may be grouped generally as:

OUTLINE STITCHES: Back stitch, double running stitch, outline stitch, running stitch, split stitch and stem stitch.

FREESTYLE FILLING STITCHES: Eyelets, satin stitch, split stitch, stem stitch, straight stitch and surface satin stitch.

FREESTYLE FILLING STITCHES USEFUL FOR SHADING: Encroaching satin stitch, and long and short stitch.

COUNTED THREAD FILLING STITCHES AND TECHNIQUES: Cross stitch, double darning, Gobelin stitch, long-armed cross stitch, Montenegrin cross stitch, surface darning, two-sided cross stitch and two-sided Italian cross stitch.

COUNTED THREAD STITCHES USEFUL FOR SHADING: Brick stitch, Florentine stitch, Hungarian stitch and tent stitch.

STITCHES AND TECHNIQUES USED TO ADD TEXTURE: Chain stitch, couching, detached buttonhole stitch, eyelets, knots, plaited braid stitch, rococo stitch and Romanian stitch.

STITCHES AND TECHNIQUES USED TO CREATE TEXTURE BY MANIPULATING THE GROUND FABRIC: Cutwork with buttonhole fillings, cutwork with hollie stitch, drawn thread work with buttonholed bars, drawn thread work with overcast bars, drawn thread work with needle-woven bars, and pulled thread work.

Select Bibliography

Ashton, Leigh. *Samplers* (London, The Medici Society 1926)

Christie, Mrs Archibald. *Samplers and Stitches. A Handbook of The Embroiderer's Art* (London, Batsford 1920)

Clabburn, Pamela. *Samplers* (Princes Risborough, Shire Publications 1977)

Colby, Averil. *Samplers* (London, Batsford 1964)

Emery, Irene. *The Primary Structures of Fabrics* (Washington DC, The Textile Museum 1966)

Ewles, Rosemary. *One Man's Samplers: The Goodhart Collection* (London, The Embroiderers' Guild, for exhibition at Orleans House Gallery 1983)

Huish, Marcus. *Samplers and Tapestry Embroideries* (London, The Fine Art Society 1900; reprinted New York, Dover 1970)

Humphrey, Carol. *Fitzwilliam Museum Handbook: Samplers* (Cambridge, Cambridge University Press 1997)

King, Donald. *Samplers* (London, HMSO 1960)

Tarrant, Naomi. *The Royal Scottish Museum Samplers* (Edinburgh, Royal Scottish Museum 1978)

Thomas, Mary. *Dictionary of Stitches* (London, Hodder & Stoughton Limited 1934 and subsequent reprints)

Trendell, PG. *Catalogue of Samplers, Victoria and Albert Museum* (London, HMSO 1915)

Walton, Karin. *Samplers: Catalogue of the Collection of Samplers in the City of Bristol Museum & Art Gallery* (Bristol, City of Bristol Museum & Art Gallery 1983)

Wanner-JeanRichard, Anne. *Muster und Zeichen / Patterns and Motifs: Catalogue of Samplers, St Gallen Textile Museum* (St Gallen, Textile Museum 1996; text in German and English)